THE WORLD WEAVER

The World Weaver

a novel

Craig Etchison

2001 · FITHIAN PRESS, SANTA BARBARA, CALIFORNIA

Published by Fithian Press
A division of Daniel and Daniel, Publishers, Inc.
Post Office Box 1525
Santa Barbara, CA 93102
www.danielpublishing.com

LIBRARY OF CONGRESS CATALOGING-IN-PUBLICATION DATA
The world weaver : a novel / by Craig Etchison.
 p. cm.
Summary: Larkin, a world weaver from a different dimension, enlists the aid of three high
school students to try to save the world from a powerful, evil "weaver" who plans to destroy
Earth and its universe.
 ISBN 1-56474-359-4 (pbk. : alk. paper)
 [1. Space and time—Fiction.] I. Title.
 PZ7.E845 Wo 2001
 [Fic]—dc21

 00-010308

To Mom and Dad
Jeanette and Bill
Page and Cindy

THE WORLD WEAVER

CHAPTER 1

"Larkin's like so weird," declared Kristi to her three friends as they trooped through the bustling halls of Newville High toward their last class of the day.

"I don't think he's weird," said Carla.

Peggy listened to her friends talk about Larkin, the new boy in school. Peggy hadn't seen him yet.

"He's so cute," said Annabelle breathlessly. "I'd love to go out with him."

Annabelle often spoke breathlessly when she talked about boys, which was most of the time. Peggy couldn't understand why anyone would talk that way. Annabelle sounded so artificial—so fake. Sometimes, when Annabelle was being especially breathless, Peggy wanted to give her a good shake and tell her to talk normally. Peggy never did, though. She didn't want to hurt Annabelle's feelings.

"You'd like to go out with every cute boy in school," Kristi said to Annabelle.

Peggy heard the sarcasm in Kristi's voice, which was normal when Kristi talked about boys. Peggy figured Kristi used sarcasm to make it seem like she didn't care about boys. Kristi had never had a boyfriend—or ever been asked out. Of course, neither had Peggy.

Peggy liked Kristi. Kristi said what she thought, which sometimes got her in trouble, but Peggy always knew where she stood with Kristi. And when Kristi made a mistake, she always admitted it. Peggy liked that. Peggy knew people who never admitted a mistake about anything, even if it meant lying.

The four girls had been together since first grade. Last year, their first year in high school, they vowed to remain friends for life.

"Carla would like to go out with Larkin," said Annabelle.

Carla giggled self-consciously, making her curly, black hair bob up and down. "Not true."

"Yes you would," agreed Kristi. "If Larkin asked you out, you'd go in a second. Even if he is shorter than you—and that's *really* short."

"And you wouldn't go out with him?" retorted Carla.

"I'd have to know him better." Kristi tried to act indifferent.

9

"What do you think of Larkin?" asked Carla, half turning to Peggy, who lagged behind.

"I haven't seen him," Peggy replied. "But what's the big deal? We get new guys coming to school all the time."

Newville was a small city of 25,000, and having new people in school wasn't unusual, but for some reason, Larkin seemed to be the topic of conversation among all the girls the first day of school. Peggy was frustrated that she was the only one among her close friends who hadn't seen him. She didn't like being last in anything, and she hated waiting on things—whether a birthday present or going to the latest movie at the mall. Not getting a glimpse of Larkin during the day had been worse than waiting in the dentist's office to get a tooth pulled.

"Maybe he'll be in our English class," said Annabelle. English was the only class the four girls had together. Kristi said the principal had conspired to keep them apart. In previous years, they had been in the same classes all day.

"Hi, Peggy," said a short, heavy-set girl wearing glasses with thick lenses.

"Hi, Regina. How are you?"

"Good. I'm glad school's started. I like seeing my friends. See you." Regina trudged off, a smile on her face. She hummed to herself as she disappeared into a crowd of milling students.

"You talk to that retard?" asked Annabelle, turning up her nose and giving Peggy a look that said *how yucky*.

"She's not a retard," Peggy snapped.

Annabelle raised her eyebrows but didn't respond.

"Why is she always humming?" asked Carla. "That's a little strange, isn't it?"

Peggy hated people making fun of Regina. True, Regina wasn't a good student, and she couldn't read well, but she was a person with feelings just like everyone else. Peggy had tutored Regina in math the previous year, and at the end of one tutoring session, Regina told Peggy how much it hurt when people made fun of her. Regina even cried, which made Peggy want to cry. From then on, Peggy tried to be extra nice to Regina and always helped her with homework when she asked.

"Look," squealed Carla, forgetting Regina. "Larkin's going into our English class."

"I hope I can sit close to him," sighed Annabelle as she began to

hurry down the hall, the leather heels of her loafers clicking loudly on the marble floor.

Peggy said nothing. She would get to see him—finally. Now she could make up her own mind about him, though if Kristi said he was a snob, he probably was. Kristi had good intuitions about people.

Larkin sat in a seat by the window when the four girls bustled in. Annabelle claimed the desk next to Larkin and smiled triumphantly to her friends. Peggy sat behind Annabelle. Papers rustled, desks scraped on the floor, and students chatted with each other, catching up on late summer happenings, comparing classes and teachers, and sharing gossip about who was still dating and who wasn't. Quite a few changes in couples had taken place over the summer. They always did.

The bell rang, and Mrs. Clapper began a general introduction to the class. Peggy felt lucky to have Mrs. Clapper. She was a super teacher. But Peggy, who was usually attentive, didn't hear a word Mrs. Clapper said. She couldn't keep her eyes or mind off Larkin.

He's cute, though he has kind of big ears. His mouth is a little wider than normal, too. And he's short. Really short. His feet barely touch the floor. He's probably the shortest boy in the class—or maybe the whole school. He looks like he should be in junior high. Why am I attracted to him? I must be six inches taller than he is. We'd never look right together. Still, there's something about him...something intriguing. Yeah. That's the word. Intriguing.

Larkin kept his eyes on his notebook as he took notes.

Why's he taking notes? No one else is. Not on the first day. Not cool. So why am I attracted to him? I've never been attracted to a boy so quickly. I feel like I've just spun around like a ballerina and gotten dizzy. Confusing. But nice.

The bell rang ending class, and students tumbled out of the room like leaves on a fall day caught in a gust of wind. Only Peggy and Larkin remained seated. She watched Larkin collect his books and start for the door. He glanced at Peggy for a moment and smiled shyly before disappearing into the noisy hall.

He's not a snob. Maybe he's unsure of himself because he's in a new school. Not stuck up, though. I'd like to get to know him. Peggy felt a flock of butterflies rise in her stomach.

The halls emptied quickly. Sunlight slanted through the windows, reflecting off hundreds of little dust particles dancing gaily in the air, as if celebrating the end of the school day. Most of the students, freed from teacher restraint, evaporated like water tossed on a hot grill. Only a few slowpokes remained, along with two or three

couples holding hands before they had to separate for that eternity between the end of school and the next morning. The sounds of the last few locker doors banging shut echoed down the hall.

Peggy stared at the floor as she walked slowly toward the main entrance.

"Hi, Peggy."

Peggy flinched. She didn't know anyone was around. "Hi," she stammered as she looked down at Larkin, who had fallen in step beside her. Her heart skipped a few beats and butterflies flapped furiously in her stomach. "How'd you know my name?"

"I listened when Mrs. Clapper called roll. I figured that was a good way to learn names. It always helps meeting new people when you know their names."

Larkin smiled up at Peggy. She liked the open, honest look in his clear blue eyes. She saw nothing shifty in his eyes like she did in some boys she knew, boys she would never trust to tell the truth no matter how good-looking they were, boys like Donnie Himler.

"You learned everyone's name just by hearing roll called?" *Awesome. I can't imagine having a memory like that. He must be a genius. He won't be interested in me.*

"It's not too hard if you concentrate," explained Larkin, a serious look on his face. "I know everyone in all my classes." He wasn't boasting. He was just giving a piece of information no more unusual than if he had said the Atlantic Ocean is on the east coast of the U.S.

"I couldn't do that if someone offered me a million dollars," said Peggy, shaking her head. "I have trouble remembering what my grandmother wants me to get at the store. Hey, if you ride a bus, you better hurry, or you'll miss it."

"I don't ride a bus. I live on Park Street."

"That's close to where I live. Which house do you live in?"

"The last one on the left."

"That's the old Miller place, isn't it?"

"I think so. Where do you live?"

"On Colonial Circle. That's just two blocks from Park."

"Great. Maybe we can walk to school together?"

"Sure." *I can't believe we're talking like this. I hardly know him, but he acts like we've been friends forever. It's almost too good to be true. It'll be neat to walk to school with him. Just walking down the hall with him feels good. I've never felt this comfortable around a boy before.*

"Are you going home now, or are you a cheerleader?"

Peggy laughed self-consciously and pulled her books close to her chest. "No, I'm not a cheerleader." *Is he messing with me? Can't he see I'm not pretty enough to be a cheerleader? I hate being skinny. It's so embarrassing. Cheerleaders don't wear braces, either.*

"Want to walk home together?"

"Sure." Peggy couldn't stop the smile spreading across her face, and she didn't even think about her braces.

"Hi, Peggy," said a voice from behind.

Peggy turned to find Regina smiling, fish eyes staring through thick glasses.

"Hi, Regina. How was the first day?"

"Okay. But school's going to be harder this year. Math scares me."

"Remember what we said last year. The first thing is not to be afraid. Besides, I'll help you with math whenever you need it."

Relief filled Regina's face. "Thanks. I was hoping you'd still help me. But I'm never sure. People change." Her face darkened at some thought she kept to herself. "As soon as I get homework, I'll tell you."

"Good. We'll show everyone you can do it."

"Who's your new friend?" demanded Regina, abruptly switching the conversation as she peered at Larkin.

"This is Larkin. He just moved to Newville."

"Hi, Larkin," said Regina and stared at him with the unblinking eyes of an owl. "Will you be my friend?"

"I'd like to be your friend, Regina."

"He doesn't know about me, does he?" Regina giggled and looked away.

"Regina!" snapped Peggy, and frowned at her friend.

"I'm sorry," replied Regina, who hung her head and shifted her weight from one leg to the other.

"You promised. Remember?"

"I remember, but sometimes I forget."

"Everyone forgets sometimes," said Peggy, unhappy that she had gotten angry. "Try to remember that you don't have anything to be ashamed of."

"Okay, Peggy. You won't be mad will you?"

"Of course not, Regina. We're friends."

Regina smiled again. "Friends. And Larkin said he'd be my friend, too. That's good. I like having a new friend. I'll see you tomorrow."

Regina turned and plodded heavily down the hall on some errand known only to her, humming a tune as she went.

"You take care of her, don't you?" said Larkin as he watched Regina disappear around a corner.

"I try. Just because her mind is a little different shouldn't give anyone the right to make fun of her. I get mad when people are mean to her. She has feelings like the rest of us."

"Yes, she does," agreed Larkin quietly, almost as if talking to himself. "She's special, too. She's more special than anyone can imagine."

Peggy glanced down at Larkin, thinking he was making fun of Regina, but Larkin had a serious expression on his face. "What do you mean?"

"Oh, nothing," he said, his face brightening as he spoke. "Just thinking to myself."

Had she known Larkin better, Peggy would have pestered Larkin unmercifully until he told her exactly what he meant about Regina being special. But she didn't know him well, so she plugged up her curiosity in a little bottle and put it on a shelf in her mind. But the cork was close to blowing off.

Peggy and Larkin left the building by the main entrance. Buses noisily pulled away from the curb, coughing out clouds of gray-blue smoke. She could hear the laughter and yells of students happy to be finished with school on a warm autumn day. It seemed that a thousand eyes peered from bus windows. Peggy hoped that at least one of her friends–they all rode buses–would see her with Larkin.

Peggy and Larkin left school by a gravel walk that wound between the football field on the left and the soccer field on the right. Sounds of kicked soccer balls blended with sounds of kicked footballs and slapping shoulder pads. The thick fall grass glistened in the heavy golden rays of the sun. Grasshoppers scattered in erratic flight, and cicadas hummed mournfully.

Fall always made Peggy sad. Only an eye-wink ago, the summer stretched out before her with endless golden possibilities. Now, summer had evaporated, as had the possibilities. She faced the tedium of school with little enthusiasm. Most classes bored her. She thought that most teachers were bored, too.

Larkin paused and stared at the football field. "He's good, isn't he?"

"Who?"

"Donnie Himler."

"Yes. And he knows it, too," said Peggy, making no attempt to hide her dislike.

"You don't like him?"

"He's totally disgusting."

"What do you mean?"

Peggy paused. She didn't like gossiping, which often led to people getting hurt, especially when stories weren't true. But this was different. She knew the truth about Donnie. "Donnie likes to hit girls–sometimes pretty hard if the girl doesn't do what he wants. That's why I can't stand him."

"Do people know?"

"Most people. I heard about it long before I knew for sure."

"How do you know for sure?"

"One of my friends went out with him, and he hit her. She had a big bruise on her arm."

"If he hits girls, why do they go out with him?"

"Status, I guess."

"So they can say they're going out with the best athlete in school?"

"I guess. It doesn't make any sense to me. At least Carla had the brains to stop dating him after he hit her the first time."

Larkin said nothing more as they walked home. He seemed wrapped in thought. Peggy walked quietly at his side, surprised that she didn't feel uncomfortable with the silence. Normally, when she was around a boy, or even in a mixed group, any kind of silence made her stomach twist into a tight knot. Not today. Not with Larkin.

"Want to stop by my house before you go home?" asked Larkin when they reached the corner of Park Street.

"Sure," replied Peggy, surprised that saying *yes* had been so easy. No boy had ever asked her over to his house before.

The Miller place looked even shabbier and more run down than when she had seen it last–a couple of years before when one of the Miller girls had asked her over. The Millers were notorious for not taking care of their property. Peggy even heard her grandmother, who never said anything negative about anybody, make some comments about the condition of the Miller place. Tall, brown grass filled the yard. Weeds choked the flowerbeds, and grass grew in the cracks of the long walk that led to the house.

The two-story Victorian house had once been painted white, but

the years had turned the paint sickly gray. Reddish-brown grime covered the windows.

Peggy shivered. She couldn't imagine living in such a place. There might be rats inside. Peggy loved animals and would pick up a snake without a second thought, but she hated rats. She didn't know why.

Larkin opened the front door, and Peggy stepped into one of the biggest surprises of her life. For a moment, she stood like a statue in the doorway as she stared into the house.

"May I come in?" laughed Larkin, who had been blocked from entering.

"Oh, sure," stammered Peggy, stepping quickly into the room. "This surprised me." She waved at the room.

"Why?" asked Larkin.

Peggy blushed, and she was sure the blush showed through her summer tan. "Well, like, you know, from the outside, and all, I just didn't expect the inside to be so awesome." *This is like pictures I've seen in the decorator magazines at Kristi's house. How does anyone keep hardwood floors polished like this? They look like they're covered with glass. What a chandelier. The oriental rugs are spectacular. They must have cost a ton of money.*

"You like it?" asked Larkin with grave eyes as he searched Peggy's face.

"I'll say. I've never seen a house like this before. It's so cool."

"Then it's okay?" Larkin asked, uncertainty in his voice.

"Are you kidding? This is the neatest house I've ever been in. I wouldn't have believed it–especially after seeing the outside."

"The outside?" Larkin looked puzzled.

"Yes. You know. The grass needs to be mowed, and the house needs paint. Stuff like that. But I guess your parents have been too busy fixing up the inside to worry about that, huh?"

"I only have a mother."

"Oh, I'm sorry. I didn't know." Peggy felt rotten. She knew what it was like to be without parents, knew how it hurt inside when the subject came up. Both her parents had been killed in a car accident when she was a baby. It wasn't any fun growing up without them. She had a terrific grandmother, but that wasn't the same as having her parents.

"That's okay. Come into the study. Do you want some milk and cookies?"

"Sure."

Peggy liked the study, which was paneled in dark walnut, with lots

of shelves crammed with books. The chairs and sofa were black leather, real leather–not the fake stuff. The room had a wonderfully musty smell, like the little leather shop in the mall. A thick, oriental carpet with designs in deep reds and blues covered the floor. Peggy sank into one of the leather chairs. She didn't feel the least bit uncomfortable being alone in the house with Larkin. That surprised her.

Larkin returned with glasses of milk and Oreo cookies. Oreos were Peggy's favorite. She loved to dunk Oreos in milk until they were about to disintegrate, then pop them into her mouth. She couldn't decide whether it would be okay to dunk them now, so she waited to see how Larkin ate his. Her grandmother always said the best policy if you weren't sure how to eat food was to watch the people you were with. Larkin didn't dunk his, so Peggy didn't either.

"What's your Mom do?" asked Peggy.

"Do?"

"Yeah. She must have a good job to afford all this."

"Oh, right. She works for a big corporation. She travels a lot."

"Kind of lonely for you, isn't it?"

"Not really. I'm used to it. Still, I'm glad you stopped by. I'd like to make some friends here."

"You will. Lots of kids at school are interested in you." Peggy giggled.

"Why'd you giggle?" asked Larkin.

"I probably shouldn't say anything, but a couple of my friends think you're cute." *I can't believe I said that. Dumb. What if he decides he likes Carla or Annabelle better than me? They're both so pretty. What if he wants to date one of them?*

Larkin blushed and looked away.

"I won't tell them I said anything," declared Peggy conspiratorially. "Don't worry."

"Thanks," said Larkin, relief flooding his voice.

For a brief moment, tension filled the air, and Peggy wondered if she had ruined her friendship with Larkin before it had even begun. Then Larkin smiled at her, and the tension disappeared, like darkness disappears when a light is turned on.

"Want to listen to some music?" asked Larkin.

"Sure."

"What do you like?"

"Oldies."

"Oldies?" Larkin seemed puzzled.

"Yes. You know, Elvis and the Beatles. Stuff from way back in the fifties and sixties."

"Oh, right. Is there a station that plays oldies?"

"I'll get it." She quickly found the station. She turned the volume down because she wanted to talk more than she wanted to listen to music.

"Thanks for stopping by, Peggy. It's great to have someone to talk to."

"Thanks for asking." Peggy blushed again.

"Will you come back again?"

"Only if you ask." Peggy laughed, amazed that she could joke with a boy she liked so much, but had only just met. "Is your mother home?"

"She's at work."

"I'd like to meet her. Listen," continued Peggy, caught up in the rush of an idea, "could you and your mother come to a picnic on Friday night? My grandmother loves having picnics, and it would be a good way for you and your mother to meet some new people. I'll ask Kristi, Carla, Annabelle and their folks. What do you think?"

"I don't know," stammered Larkin. "Mom is so busy, and I never know if she's going to be home."

"Ask her. We'll have a great time. Please."

"Okay." Larkin smiled. "If it's that important, I'll do my best to get Mom to come."

"Even if she can't, you have to come."

"Okay. I'll come."

"Promise?"

"Promise."

CHAPTER 2

Peggy, Carla, and Kristi sat on the front porch of Peggy's house, waiting for Larkin and his mother to arrive for the picnic. Annabelle hadn't been able to come. "What's Larkin's mother like?" asked Carla.

"I don't have a clue," replied Peggy. "Larkin didn't tell me much, except that she travels a lot."

"What's his house like?" asked Carla.

"The inside is awesome–real expensive looking, so his mother must make lots of money." She didn't know what else to tell her friends.

"Mighty funny," said Kristi. "He's strange to start with. No one has seen his mother. And living in the old Miller house. Who would want to live in that dump? Weird if you ask me."

"Wait a minute," said Peggy defensively. "There's nothing strange about Larkin. He's the nicest boy I've ever met."

"But you're in love, so how would you know?" said Kristi.

Carla grinned, and Peggy felt her face get hot as she unsuccessfully tried to think of something to say.

"Oh, jeez," exploded Kristi. "Look at that."

"Unbelievable," said Carla. "Is that Larkin's mother?"

The three girls sat with wide eyes and open mouths as Larkin and his mother marched up the street toward them.

Larkin's mother, a tall, large woman, wore a red and purple silk dress that reached to her ankles. It billowed in the breeze, like a sail, and appeared to pull her along at a great rate. Her fiery-red hair looked like it had been frizzed by a bolt of lightning.

"Hi, Peggy," said Larkin breathlessly, as he and his mother surged up to the porch. "Mother, this is Peggy McClean, Kristi Cutlip, and Carla Hernandez."

"Hello, Mrs. Prentice," stammered Peggy, feeling awkward in the presence of the strange-looking woman.

"How do you do," gushed Mrs. Prentice in a deep voice, heartily shaking each girl's hand. "It's so good to meet some of my baby's friends. Friends are so important, don't you agree? But now, I see

19

that my boy has perfectly delightful friends. I don't know why I worry myself about him. But, then, that's the role of a mother, is it not? But where are your parents?"

Overwhelmed, as if a wave had crashed over her, Peggy meekly opened the door and led Mrs. Prentice and Larkin through the house to the patio in back, where Mr. Cutlip was preparing the charcoal grill.

"Is she for real?" asked Carla when Peggy returned. Carla and Kristi had remained on the porch after Mrs. Prentice blew through the front door.

"Where's Larkin?" asked Kristi.

"With his mother."

"Did you see her makeup?" asked Kristi.

"Totally disgusting," responded Carla.

"And the color of her lipstick? Have you ever seen a more outrageous orange?"

"What about the purple nails? No one that old can wear purple on her nails." Kristi snickered.

The girls continued to giggle as they followed Peggy through the house to the patio. Even Peggy couldn't help laughing. She'd never met anyone like Mrs. Prentice.

"I've never seen so much gold jewelry in all my life, have you?" Peggy asked no one in particular.

"She could open a jewelry store," said Carla, as they stepped out on the patio.

"Dahling," Mrs. Prentice gushed over Kristi's father with a pronounced southern drawl. "This looks like a beautiful fire you're building. You must be quite expert at building fires. I've never been able to build a fire—well, I mean a cooking fire. You must teach me. It would be so useful to know, what with not having a man about the house." She fluttered large, false eyelashes.

Bill Cutlip made no effort to hide his unease, an unease that grew as Mrs. Prentice placed one hand on his shoulder and pressed close to him.

"Isn't he just wonderful, building this fire," Mrs. Prentice said loudly. "Why, what is a man if he can't build a fire, I always say."

"I think she's hitting on my dad," exclaimed Kristi, surprised and angered by Mrs. Prentice's flirtations.

Abruptly, Mrs. Prentice whirled away from Bill Cutlip and strode across the patio to Carla's father. "Dahling, what a cute name

Roberto is. Do you come from Me-hi-co?" She laughed gaily as she pronounced Mexico the way a grade B actress might pronounce it in a bad western movie.

"Yes, señora, I do."

"You're so cute, Roberto. I like dark men with dark eyes. Why, I could eat such men up. But I'm sure you have many women after you, now don't you?"

"No, señora. I'm happily married." Roberto smiled uneasily at his wife, his eyes pleading for help.

"Oh, my, you naughty man. Happily married. That's quite something. And for someone so handsome. The dark Latin lover. Well, I won't ask more. I don't want to intrude, you know. But tell me, how do you come to be living in the States?"

"My wife and I met in college, and I stayed in the United States after we married."

"How utterly romantic. Are you a romantic, Roberto?" Mrs. Prentice fluttered her large eyelashes. "I'm a romantic. I couldn't live without romance. It's the nectar that keeps me alive, that makes life worth living, don't you think?"

"I don't know, señora. Now, if you'll excuse me, I think my wife wants me to help her with the salad."

"But of course, dahling. Of course. We shall talk more later. Mrs. McClean?"

"Please. Just call me Wilma," said Peggy's grandmother, trying to be polite to her guest, but unable to keep an edge out of her voice.

Peggy groaned. *Grandma isn't happy. When her eyes get that look, I know she's mad. She'll never like Mrs. Prentice. This isn't working out like I wanted.*

"Wilma, then. Do you have something to drink? I would absolutely adore a gin and tonic," Mrs. Prentice said gaily. "I can't endure a warm day without a cool gin and tonic. Wonderfully refreshing. Relaxes the nerves, I think."

The patio went quiet, as if a pump had sucked every sound out of the air, and Peggy saw the sparks in her grandmother's eyes burst into flame.

"We don't serve alcohol in this house," she announced. "A drunk driver killed Peggy's parents."

"Why, how utterly tragic, my dear. I understand. I see perfectly why you have no alcohol in the house. Quite all right. I brought a little something of my own, just in case, you understand. I, too, have

lost a loved one," she said dramatically, as she raised her eyes to the sky.

From a hidden pocket in the folds of her dress, Mrs. Prentice produced a flask and proceeded to take a long drink as everyone looked on in astonishment. "Ah, just the thing after a long day. Would either of you gentlemen like a touch?" She waved the flask at Bill and Roberto, who both shook their heads in embarrassed silence.

"It's very good, you know, especially for the digestion. If I don't have a little drink before dinner, my food just doesn't digest properly." She took another long drink, then slipped the flask back into the folds of her dress.

"Well, I never in all my days," said Wilma as she stomped to the kitchen for the pickle tray.

"Wow. Your grandmother is steamed," whispered Carla, her eyes wide. "I've never seen her angry before."

Peggy nodded, stunned by her grandmother's anger. *What's going to happen next? Grandma is furious. She'll be mad at me for suggesting this picnic. She won't want me to have anything to do with Larkin. This is the pits. I hope dinner doesn't last long.*

Larkin walked over and sat beside Peggy. "This is really nice of your grandmother. Mom hasn't had a chance to meet anyone before now. She appreciates what you're doing." He smiled.

Peggy looked closely into Larkin's eyes and saw only innocence and sincerity. *Doesn't he understand how awkward his mother has made everyone feel? Doesn't he know how rude his mother was when she drank in front of Grandma? Can't he see how uncomfortable his mother made Mr. Cutlip and Mr. Hernandez when she threw herself at them? Disgusting. Mothers shouldn't act that way.*

"Oh, you're just too cute for words," gushed Mrs. Prentice loudly, as she swept up to Peggy and Larkin.

Peggy blushed and dropped her eyes. *This is so embarrassing. This is worse than that time I fell in front of the whole junior high in that stupid play. Why doesn't she leave us alone? I can't believe Larkin has such a mother.*

"You two belong together. I can see that," continued Mrs. Prentice. She turned and smiled at Bill Cutlip. "Don't you think these adorable children belong together?"

Bill cleared his throat. "I hadn't thought about it. I don't think we want to put undue pressure on the kids, now do we? After all, they're only in tenth grade."

"Oh my, no. No pressure. Of course not. But it's so obvious.

They were meant for each other. I feel these things very deeply," she said dramatically, as she towered over Larkin and Peggy.

Peggy wanted to crawl into a hole and die. Her friends would never let her forget this. She could hear Kristi at school on Monday loudly mimicking Mrs. Prentice.

"Peggy, would you help me in the kitchen?" asked her grandmother.

"Thanks, Grandma," sighed Peggy when they reached the safety of the kitchen. "I thought I'd die out there."

"No wonder, child. That woman is unbearable. Why on earth did you ask me to have this picnic?"

"I didn't know, Grandma," replied Peggy, tears welling up in her eyes. "Larkin is so nice. I didn't know his mother would be like this."

"Poor child. Putting up with her is bad enough for us adults. I'm sure it's torture for you. We'll just have to see the evening out. I'm sure the Cutlips and the Hernandezes won't stay long after we've eaten, so we'll hope she has enough sense to leave when they do—though I have my doubts."

"I'm sorry, Grandma. I didn't mean to cause trouble."

"Now, don't you fret, dear. Sometimes things like this happen, no matter how good the intentions. That's part of life. But I'll have to admit, I'd like to give that woman a piece of my mind, I would."

As soon as the remains of the picnic were cleared from the table, Bill Cutlip said, "We must be going, Wilma. I have a good deal of work to do in the morning."

"Surely you're not leaving already," said Mrs. Prentice. "Why, the evening is young, and we've barely had a chance to get to know each other."

"I'm sorry we have to leave, but duty calls," said Bill, shrugging his shoulders and trying to smile apologetically.

"But do stay, you dear man. Make an exception for me." Mrs. Prentice tried to smile alluringly, though Peggy could only wince at the absurdity of her flirtations. Carla and Kristi giggled.

Mrs. Prentice produced her bottle again from the folds of her dress. "Won't you gentlemen have a little nightcap with me before you depart? Just to be sociable?"

"We don't have sociable drinks in this house, Mrs. Prentice," snapped Wilma, making no attempt to hide her anger.

Peggy cringed as her grandmother spoke, but Larkin seemed oblivious to the tension filling the air.

"Oh my, you do miss a good thing. But it's your house and your rules, though I think I'll have just a little sip. It's good for my digestion, you know."

A few minutes after the Cutlips and Hernandezes drove away, Mrs. Prentice announced she would leave. "After all," she said, "we don't want to overstay our welcome, now do we, Larkin? This has been absolutely delightful, Wilma. I did so enjoy meeting some of Larkin's little friends. Now, you simply must come and visit me, though, I must say, I am often out of town on business."

Peggy watched her grandmother smile stiffly, and not reply to the invitation. She would never visit Mrs. Prentice.

"And Peggy," continued Mrs. Prentice, smiling down at her, "you must stop by the house often. Larkin does enjoy your company, and I approve of him having a nice friend."

Mrs. Prentice leaned over and patted Peggy on the head. Peggy wanted to tell her that she wasn't a baby or a dog. Being patted on the head infuriated her.

"Hey, Peggy," Larkin whispered hurriedly as his mother talked on to Peggy's grandmother. "Will you have lunch with me tomorrow at the Pizza Parlor?"

The day before, that question would have made Peggy the happiest girl in Newville, but coming, as it did, on the heels of a terrible evening, she wasn't sure she wanted to go anywhere with Larkin. Still, she saw the same curiously innocent look in his eyes, and she didn't want to hurt his feelings.

"Sure."

"Is eleven okay?"

"Fine."

"Meet you on the corner?"

"Okay." The corner was where they met on weekdays to walk to school together.

Mrs. Prentice finally blew off into the evening twilight with Larkin in tow. Peggy heard her loudly talking to Larkin as they walked quickly down the sidewalk.

"I've never met a ruder person in my entire life," exclaimed Wilma McClean as she went back into the house. "Never again. Never again," was the last thing Peggy heard her grandmother mutter to herself.

Next morning, Peggy waited nervously on the corner for Larkin. The day had already turned warm, more like summer than fall, and

the afternoon promised to be hot. Peggy was sorry the swimming pool had closed for the year.

"Hey, Peggy." Larkin bounced down the street, his face all smiles. "Gosh, that was a good picnic last night. We really enjoyed it. Thanks."

"That's okay," replied Peggy. *He doesn't have a clue about what happened last night. How's that possible? Didn't he see how angry Grandma was? Didn't he see how his mother embarrassed Mr. Hernandez? I can't figure him out.*

"You liked my mother, then?"

"Sure," Peggy lied.

Larkin stopped walking and looked up into Peggy's face, making her feel suddenly uncomfortable, like when she didn't quite tell the whole truth, and her grandmother would look quietly into her eyes until she told everything.

"No you didn't. You're not telling the truth."

Peggy felt her stomach go queasy. *How'd he know that? What do I do? I like Larkin. I want him to like me. I hate being dishonest. But if I tell the truth now, I might lose his friendship. I don't want that. Still, I can't lie—not with him looking at me that way.*

Before Peggy could say anything, Larkin spoke again. "Why didn't you like her? Didn't she act like a mother is supposed to?"

Peggy looked down at Larkin in total disbelief. His eyes were wide and innocent, not the slightest hint of deception in them.

"Larkin," Peggy said, "mothers don't act the way yours did. She embarrassed everyone, and she made my grandmother furious. Is your mother like that all the time?"

"All the time?"

"Yes—you know, like when she goes to work?"

"I guess so."

"How does she keep her job?" asked Peggy in wonder.

"I don't know. What's wrong with Mother?"

Peggy felt like a small cork floating down a wide river. Larkin didn't seem to have any idea how bizarre his mother had acted, not to mention dressed. Peggy continued walking toward the Pizza Parlor, her mind in a whirl.

"You don't think she made a very good mother?" asked Larkin.

"What a crazy question. I just mean that she acted very differently from what people expected. She may be a perfectly good mother. After all, she raised you, and I think you're super."

"What was different about her?" Larkin asked seriously, as if he were trying to solve a complex problem.

"Oh, Larkin," said Peggy, a hint of irritation in her voice. "Surely you saw the way your mother flirted with Kristi's father?"

"That's not okay? Don't women do that?"

"Of course women do that, only they don't do it with married men at a picnic like we were having."

"Oh. I didn't know."

"Larkin, there are times when I think you come from another planet."

"Because there are lots of things I don't know?" Larkin looked unhappy.

"Yes. But look, I really like being your friend," she added hurriedly. She didn't like seeing Larkin so unhappy.

"Why didn't you tell me the truth about my mother right off?"

Peggy shrugged. "I didn't want to hurt your feelings."

"But telling the truth would never hurt my feelings. It's only when people don't tell the truth that my feelings get hurt. Don't you understand that?"

"I'm sorry, Larkin," Peggy said softly. "I always want to tell the truth. But sometimes, if I think the truth will hurt, I might not be totally honest–especially if I'm talking to someone I really like. Understand?"

"I guess so. But if you think someone is special, that's even more reason to tell the truth." He paused before continuing. "Tell me more about why people didn't like my mother. I want to understand."

"It's hard to talk about, Larkin."

"You've got to tell me, Peggy. How else am I going to learn? She made people mad, huh?"

"Mad and uncomfortable–especially my grandmother." Peggy laughed quietly at the memory of her grandmother fuming about the house after the picnic. "I've never seen my grandmother that mad before."

"Why was she mad?"

"The drinking, mostly."

"The drinking?"

"Larkin, there are times when I can't believe how little you know." Peggy looked up at the sky in exasperation. "Yes, the drinking. Your mom offended everyone when she brought out her flask. Guests just don't do that at someone else's house."

"Oh. I thought that was okay."

"Why would you think that?"

"From the movies I watched on American Movie Classics."

Peggy couldn't believe what she was hearing. "What do old movies on AMC have to do with how your mother acted?" Sometimes Peggy watched a movie on AMC, but only when she was desperate. The movies were almost always in black-and-white, and everything about them seemed so faked, especially the way people talked. Peggy couldn't imagine anyone really talking that way, though Mrs. Prentice came close.

"Tell you inside," said Larkin, as he pushed open the door of the Pizza Parlor.

CHAPTER 3

Peggy liked eating at the Pizza Parlor better than any other place in Newville. She loved the smell of freshly baked pizza crusts and the tang of sausage and pepperoni in the air. She loved pizza–any kind of pizza–though her favorite was the Supremo Special, which had eight toppings. She could eat pizza every day. Her grandmother often told Peggy she was going to turn into a pizza.

Larkin led her to a corner booth. They gave their order to the waiter, who quickly returned with their Cokes. One other person sat at the far end of the dinning room. It was early for the lunch crowd.

"What were you going to tell me about your mother and AMC?" Peggy asked impatiently. In the background, Elvis sang on the old-fashioned jukebox, but Peggy wasn't listening.

Larkin dropped his eyes as he began to speak. "This is going to take some explaining–and some trust on your part," he said slowly. "My mother–the woman you saw at the picnic–isn't really my mother."

"Well, that's a relief," declared Peggy. "She acted so weird. Not like you at all. Who was she?"

"She's no one," Larkin said softly.

"What do you mean, no one? She has to be someone."

"Not really. I've been watching lots of movies on AMC. I thought the women in the movies would make good models for the way a woman should act. So I made up my mother from what I saw in the movies." Larkin suddenly smiled sheepishly, and he blushed. "I guess I was wrong, huh?"

"Wait a minute. What do you mean you made up your mother? Either you have a mother or you don't."

"Not me, Peggy. I needed a mother for the picnic. I also thought it would be good if people saw my mother so they wouldn't think I was living alone. I wove my mother–created her from my imagination. She only exists in my imagination."

"How can your mother exist in your imagination?" *Is he totally nuts? He seems so sincere, but what he's saying makes no sense.*

The pizza arrived, all hot and cheesy and loaded with pepperoni

28

and mushrooms, but instead of grabbing a piece and inhaling it–
which is what Peggy usually did–she just stared at Larkin. *Weaving his
mother? Whoever heard of such nonsense. The world doesn't work that way. He
surely doesn't think I'm going to believe that. Is he making fun of me?*

"I have a power," said Larkin. "I can create things. I'll explain
that later, but for now, let's stick to my mother. I created her–wove
her from ideas and pictures I saw on television. I wanted her to be a
typical mother, but I guess I chose the wrong women for models."
He laughed when he finished speaking, a quick, quiet laugh, as if a
joke had backfired on him.

"Where is she now?"

Larkin tapped his forehead. "In here."

"You're putting me on, aren't you?"

"No. Really, Peggy, I'm telling the truth."

Peggy leaned back and glared at Larkin. *I can't figure this out.
Nothing about him suggests that he's lying or trying to pull a practical joke on
me, but how can I take him seriously? This is all so crazy, so insane.*

"Let me show you," said Larkin after a moment of silence. "Have
you seen my mother today?"

"Of course not."

"Right, because she didn't exist before Saturday evening, and she
hasn't existed since the picnic. I'm going to weave her back into
existence again, and in a few seconds she's going to walk out of the
restroom."

Peggy stared at the restroom door as Larkin closed his eyes.
Suddenly, the door burst open, and out blew Mrs. Prentice. She
approached their table like a Spanish galleon under full sail.

"Why, there you children are," gushed Mrs. Prentice as she
surged up to them. "I've been looking all over for you. Having pizza?
That's so nice. You make a lovely couple. I do so approve of Larkin's
choice."

Mrs. Prentice spoke loudly, and the few people now in the
restaurant stared. Some smiled. Peggy felt the color rise in her cheeks.
She didn't like being the center of attention, especially with Mrs.
Prentice looming over the table. Her sickly-sweet perfume wrapped
itself around Peggy and made her slightly ill.

"Well, it's so nice to see you two getting along. Now, I really
must go. You children have a good time." She patted Peggy on the
head before turning from the booth.

"Didn't you forget something in the restroom, Mom?"

"Oh, my, yes. Be right back." With that, she swooped off to the restroom.

"Now, I want you to do something, Peggy."

"What?" asked Peggy, still trying to figure out what to believe about Mrs. Prentice.

"Go into the restroom, and see if my mother is there."

"Of course she's there. She just went in the door."

"Please. Go look."

"Okay, but this is stupid. I saw her go in," muttered Peggy. When Peggy entered the small restroom, it was empty. She shivered. *How can it be empty? I saw Mrs. Prentice walk through the door. I can still smell her horrible perfume. But where is she? This is driving me crazy.*

"Well?" asked Larkin when Peggy came back to the table.

"She wasn't there," Peggy said as she dropped into her seat.

"I know. She's back here," replied Larkin with a little smile and pointing to his head.

"This is like so creepy."

"Not really. I can explain everything."

"It's going to take a lot of explaining."

"I know. Better do that at home, though. Are you going to eat any pizza?"

"Not now. I want to hear what you have to say. Let's take the pizza with us."

What happened at the Pizza Parlor left Peggy shaken, but she was in for another surprise almost as great. As she came to the walk that led up to Larkin's house, Peggy gasped. The grass was neatly mowed and had the deep green look of a well-watered, well-fertilized lawn. Red, orange, yellow, white, and purple mums overflowed the neatly mulched flowerbeds. The concrete walk looked new. Bright sunlight shimmered and danced off white vinyl siding. Black shutters hung neatly at every window, and each window had a new screen. The porch floor gleamed grandly in a new coat of soft gray paint.

Larkin smiled. "You like it then?"

"Awesome. When did this happen?" Peggy continued to gawk as they walked toward the house.

"A few days ago."

"I didn't know anyone could get so much done in such a short time." She shook her head in disbelief and entered the house.

"Want me to heat up the pizza?" Larkin asked.

"I'm not hungry. I want you to explain what's happened today."

Larkin dropped the pizza box on a table and turned his blue eyes on Peggy. She felt a little uneasy. She sensed a power in Larkin that she hadn't noticed before, as if he had kept it hidden and was only now allowing her a brief glimpse. The glimpse intrigued her.

"This is going to take some time and a lot of faith on your part," said Larkin.

Peggy could feel her heart skip a beat. *He can be so serious at times. He's more serious than any of my other friends, that's for sure. I like his seriousness. But something about the way he looks now, and something about his tone of voice is so different....*

Larkin gazed steadily at Peggy as he began speaking. "I wasn't born on this planet."

Peggy stared at Larkin for a moment. Then she began to laugh, a laugh that sprang from the bottom of her stomach and filled the room, like a burst of sunlight fills a darkened room when curtains are flung open. "Oh, Larkin," she gasped when the laugh ended, "I thought, the way you began, you know, so serious, that you were going to tell me something frightful. Now I find out you're putting me on. You had me going. Boy, was I a sucker."

"Peggy, what I just said is the absolute truth."

Larkin wasn't smiling or laughing, which Peggy noticed. Larkin usually laughed quite easily when they were together. She liked that about him.

"You're kidding," cried Peggy desperately, not wanting to believe the boy she liked better than any boy in the world was crazy.

"I'd never lie to you, Peggy. You know that."

"But you can't be from another planet. That stuff only happens in those stupid newspapers at the grocery store."

"Not just another planet, Peggy," Larkin continued, ignoring her comment, "but a planet from a completely different dimension."

"Oh, right. Another dimension, too. Come on Larkin. Get serious. This isn't fun anymore." *I should get up and leave right now, but I can't. I have to find out what's going on.*

"I knew it might be impossible to persuade a stranger, or an adult, to believe me, but I never realized how hard it would be to persuade a friend." Larkin sighed and leaned back in his chair, staring thoughtfully at the opposite wall.

"You expect me to believe that you're from another planet and, what did you call it, another dimension? Give me a break."

"I hoped you would believe me." Larkin's shoulders drooped.

"Well, I don't believe it. Not for a minute." Peggy paused and stared at Larkin, who looked sadder than a lost puppy, and she couldn't help feeling sorry for him. "Okay, let's pretend I believe you. Explain what you mean about being from another planet. Which planet? Mars? Venus?"

"It's difficult to explain. My planet exists in a different time and space from yours. Think of your universe–all the galaxies and stars and planetary systems that make up your universe–as being contained inside a basketball. Okay?"

Peggy nodded. She could grasp that.

"My universe–with its galaxies and stars and planetary systems and my home planet–is contained inside a different basketball. What happens in my universe has no connection with what happens in your universe. Does that make sense?"

"Sort of, though I don't see how you could move back and forth between the basketballs if they aren't connected." *What an intriguing explanation. It sounds reasonable, but how can I believe other universes are rolling around like basketballs–universes completely different from this universe?*

Larkin scrunched up his eyes, and furrows formed across his forehead as he began to talk. "We have a small group of people on my world called world weavers. I'm one of those, but I've only just begun to develop my powers. World weavers create whole universes, kind of like the weavers on earth who create pictures on tapestries."

Peggy had recently read an article in a science magazine about how large the universe was–billions of light years across, millions of galaxies, trillions of stars. She couldn't begin to comprehend the numbers. She also couldn't comprehend the idea of one person creating such a universe. The idea stunned her. "You can create a whole universe?"

"Not yet," said Larkin shyly. "It'll take many years working with a master weaver before I'll be able to create a complete universe. Someday I'll be able to, I hope."

Peggy shook her head. *Not possible. Who's he trying to kid? Create a universe. Create different time dimensions. Hopping between dimensions. That couldn't be.* "How did you get here?" she finally asked.

"I've been working with my father to develop my power. My father is a master world weaver. I can only do little things so far, but I was able to weave myself into your universe, though it wasn't easy."

"Did someone weave this universe?" asked Peggy nervously. If her universe had been woven, somehow she felt far less secure

about...everything. Couldn't it be unwoven just as easily as it had been woven?

"Your universe was woven by the greatest world weaver ever."

Peggy was confused. "If someone wove this universe, how could you weave yourself into it? Wouldn't the weaver have to weave you into it right from the beginning?"

"I could never change this universe in any major way, but even a novice like me can make slight alterations, like weaving myself here."

"Was that difficult...or dangerous?"

"A little scary. I'd never traveled alone between different dimensions before, and I wasn't sure I could do it."

"Why did you come here? Why leave your own dimension? Why are you telling me all this?" All sorts of questions welled up in Peggy's mind.

"Those are complicated questions. First, you need to know that my father wove the universe you live in."

"Wait a minute. I just thought of something. If your father wove this universe, does that mean it isn't real? That I'm not real?" *If he expects me to believe that, then I know he's a loon. I know perfectly well that I exist and that my world exists. No way he's going to make me believe anything else.*

"You're real, all right. But this reality was created by my father."

Peggy nodded, though she wasn't sure she felt any more secure than before if all Larkin said was true. She decided to go back to her original question. "But why are you here?"

Larkin took a deep breath. "My father attempts to weave only good things, but some of his creations come out better than others. He considers this universe his best and greatest creation. He's never been able to weave another universe that equals the beauty and grandeur of this one. He loves all his creations, but this one is special to him."

"Wait a minute. He's woven more than one universe?"

"Of course. Master weavers create hundreds of universes during their lives, always seeking perfection."

"There are hundreds of universes?"

"Millions, actually."

"Millions?"

"World weavers have been at work for thousands of your years."

Peggy sat back in her chair and tried to comprehend what she had just heard, without much success. "Okay...okay...but you still

haven't told me why you're here. I mean you didn't come here for a vacation, did you?"

"Two world weavers are greater than all the rest. My father is one. My uncle is the other, only, unlike my father, he weaves evil. Every time my father weaves a universe, my uncle weaves a contiguous universe that's evil, a universe created for the sole purpose of destroying my father's work."

"What does that have to do with you being here?" interrupted Peggy.

"My uncle is weaving a universe to destroy your universe. He's weaving a universe so evil that nothing will withstand its power. That universe will break into your universe and destroy everything, and my uncle is almost finished weaving it."

"How do you know all this?"

"My father told me. My father and my uncle have an ability to catch glimpses into each other's minds—perhaps because they're both so powerful, perhaps because they're brothers. I don't know for sure. My father has seen what my uncle is weaving, and he knows it will destroy your universe."

"Kind of like one basketball gobbling up another one?"

"Exactly."

"But that doesn't explain why you're here."

"My father has shown me many of his best creations. Masters do that with apprentices. When I saw this universe, and especially this planet, I fell in love with it. There's no beauty in all the creations I've seen that can match the beauty of your world. My father agrees, and he's seen far more than I have. So I'm going to try to save this universe so this wonderful planet will survive."

"But you said your powers weren't fully developed. How are you going to save a universe when you've only just learned to move between dimensions?"

"My powers aren't much," Larkin replied, a wry smile flickering across his face, "that's true. My father doesn't even know what I'm up to. If he knew, he wouldn't let me try. You know how parents are."

"Sort of," said Peggy, wishing that she did know. "What's your plan?"

"I have to get to my uncle and stop him."

"Oh, sure. One of the greatest world weavers ever, and you're going to walk up to him and persuade him to stop being a bad guy."

"So you believe what I've been telling you?" Larkin smiled.

"I don't know about that. What you've told me sounds like something from a science fiction novel, and I hate science fiction."

The house was strangely silent, as if it were listening intently to the conversation. Peggy felt uneasy again. Not afraid. She had never felt afraid around Larkin. This was a different feeling, as if she were about to make a decision that would have a major effect on her life, a decision she really didn't want to make, but one she couldn't avoid. Larkin continued to look thoughtfully at her. After what seemed an eternity, the tension in the air making time crawl more slowly than a caterpillar, Larkin spoke. "Perhaps I can prove that what I'm saying isn't science fiction. There's no danger. Okay?"

"Okay." Peggy wondered how he could prove he was a world weaver.

"How do you think this house got fixed up?"

"Your mother hired workmen to do it."

"I wove my mother the day of your grandmother's picnic. My mother never existed before then."

"You then. You could hire workers. That wouldn't be hard."

"I wove the interior of this house, Peggy. Now I'm going to undo it. Don't be frightened. Just watch what happens."

For a few seconds, as Peggy looked around the room, nothing happened. Then she noticed objects in the room shimmering, as if they were made of paper and a light breeze had rustled them. The air darkened, and objects—paintings, books, chairs, and lamps—began to fade and wink out, as if someone had turned off a switch for each object. Peggy didn't know how much time passed—it seemed only minutes, though it could have been longer—but she now sat in a dark, dirty room with paint peeling from the walls, pieces of plaster lying scattered about a scarred floor, and cobwebs hanging thickly in every corner. This was the house she had expected to find when she first entered with Larkin. She shivered.

"Now do you believe?" asked Larkin, as he stood solemnly in front of Peggy.

"You wove this house to look the way it does?"

"I found a magazine that showed home interiors. I wove what I saw in the pictures."

"I thought you said you didn't have powers—that you needed to sit at the foot of a master weaver for many years."

"I do if I want to weave a universe—or even a world. But this," he

waved at the house, "is easy as walking to school. I've been doing little things like this for years."

Peggy shivered in the damp gloom. "Can you make the room the way it was?"

"Sure." Larkin stood quietly before her, his eyes closed, forehead knit in concentration.

Peggy felt warmth spread through the room. The air shimmered again, and objects began to reappear–popping into existence as if someone had flipped a switch. In a few moments, the room looked just like it had before, right down to the painting hanging a little crookedly on the opposite wall.

"That was so awesome," murmured Peggy, at the same time wondering if she had been hypnotized.

"Do you believe me now?"

"I'm starting to. That was amazing."

"I guess it's pretty awesome the first time you see it happen."

Peggy smiled. She'd never heard Larkin use slang before.

"Now what?" Peggy asked. "Why have you told me all this? Why is it so important that I believe you?"

"I need your help."

"My help? Good golly, Larkin, how can I help you?"

"Believing that you can help me is going to take a lot more faith than believing I'm from another planet in another dimension."

"You're serious, aren't you?"

"Yes."

"You really need my help?"

Larkin nodded, and his eyes bore into Peggy.

Peggy groaned. She hadn't counted on anything like this. "Okay. Tell me how I can help, but I bet I won't like what I hear."

"First, I'm sure the solution to saving your universe lies in my uncle's castle."

"Your uncle lives in a castle?" Peggy interrupted. "Aren't castles an Earth thing?"

"Lots of worlds have castles. My uncle's castle is quite elaborate–especially the defenses."

"I don't think I want to hear about those."

"Maybe later. I came here because I have a strong intuition that I'll need your help if I'm going to save Earth."

"Wait a minute. Even if I could help you once we got to your uncle's castle, which I doubt, I can't travel between dimensions."

"I can weave you between dimensions. I almost died when I wove myself here, but what I learned will help me take you and two others back to my dimension."

"Two others?"

"Yes. Intuition again. I'm sure you and I can't defeat my uncle alone. We'll need the help of two others."

"Wait a minute. I haven't agreed to go anywhere with you. I'm not even sure I believe all this stuff."

"I know, but I was hoping." He grinned and shrugged.

"I suppose you've picked out the other two people?"

"Regina Conley and Donnie Himler."

"You've got to be kidding." Peggy shook her head in disbelief. "How are they going to help? And how do you expect to persuade them to come along? We're not talking about a trip to the beach, you know."

"Regina will come if you ask her. You're friends. Donnie will be harder to persuade, but he's crucial. Without him, I don't think we'll succeed."

Larkin is so determined. Nothing's going to stop him from trying, even though he could safely return home and probably live a long and happy life as a world weaver. All he seems to care about is Earth. Wait a minute, I'm thinking about all this as if it were real. Do I believe him? "Even if Donnie doesn't join us, will you try anyway?"

"I have to try. I didn't weave this world, but I love it. The natural beauty is like nothing I've ever seen or ever dreamed of. I don't think many of your people appreciate that. Which is sad. If they understood, they might take better care of the planet.

"The beauty of Earth's people is also special. You have so much potential for love, and when it breaks through, there's nothing like it in all creation.

"There's also you, Peggy. I know we've only known each other a short time, but you've become special to me." For a moment, Larkin gazed into Peggy's eyes, and Peggy felt all warm and safe and loved, as if someone had wrapped a warm blanket around her as she stood outside on a cold night.

Peggy considered what Larkin had said before speaking. "Tell me if I'm wrong, but I get the feeling you don't think we have much chance to defeat your uncle."

"Not much."

"What's the good of trying then? Why not just go home? No one

will ever know, and if they did, no one would blame you."

"You're right, of course," said Larkin. "I could leave, but something as beautiful as your world should be saved."

The afternoon had slipped by. The sun's rays slanted through the window of the study, much like the first time Peggy sat across from Larkin, but much had changed. Peggy felt a little knot in the pit of her stomach. *That knot is going to be with me for a while, I bet. I'm scared. If I join him, suppose I don't measure up? What if I fail when it counts? What if my weakness keeps him from saving this universe? Still, he wants my help. How can I turn him down?*

"This world must be saved," said Larkin, almost to himself.

"Will going to your uncle's planet be really dangerous?"

Larkin looked into Peggy's eyes, and she saw determination and fear. "We could die."

Peggy felt a cold tingle move up her spine. She didn't like talk of dying. She didn't like to think about dying. She didn't want to die. Not yet. She had too many years to live. Too many things to do. "And you're going there, even though you might die?"

"Yes."

Peggy sighed. She felt the tug of Larkin's commitment. But she was scared, more scared than she'd ever been in her life. As she spoke, her voice seemed to come from some other person. "When do we start?"

"You'll go?"

"I'm probably crazy, but I'll go. What do I tell my grandmother?"

"Nothing. We'll go as soon as we get Regina and Donnie to join us. We can go any afternoon or evening. No one has to know."

"How long will it take? I thought we'd be gone a few days, at least."

"We will. But no matter how long we're in my dimension, we can return to this dimension at almost the exact time we left—if we get back. It's one of the benefits of moving from one dimension to another.

"If we get back?" A cold chill ran down Peggy's back, and the room seemed less bright and warm. *He wasn't kidding about the possibility of dying. I didn't think he was, but I'd hoped it wasn't anything to really worry about.*

Larkin moved closer to Peggy. He took her hand and squeezed it gently as he looked into her eyes. "There aren't any guarantees. I don't want anything to happen to you, but if you go with me, we go

into danger. My uncle would be pleased if we died attempting to reach his castle. Even if we get to the castle, he may squash us like little bugs. I wouldn't ask you, but without you, there's little chance of success."

"I understand." Peggy's voice was barely audible.

Larkin sighed, shrugged his shoulders as if trying to throw off a heavy weight, and stared at the floor. "I hate asking others to risk their lives, and if I could do it myself, I would. But I need help."

"That's okay. I'm not going to let your uncle destroy my world without a fight." Peggy spoke with more determination than she felt, and she felt more fear than determination. "Monday we'll talk to Regina and Donnie."

Larkin smiled. "We can do it. I know we can. All we need is a little luck."

"Right. We have to think positively."

"When do you think would be a good time for Regina and Donnie to go?"

"Regina can probably come here after school on Monday. I don't know about Donnie. It's going to be hard to get him here, I think."

"Won't he have football practice on Monday?"

"Sometimes they get Monday off. Let's hope."

"You'll help me persuade Donnie?"

"I'll try, if you're sure we need him." Peggy hardly knew Donnie, but she detested him. "Isn't there someone else? I know a couple of the football players who are nice guys. I bet they'd come with us."

"We need Donnie. No one else will do."

"Okay. But getting Donnie to join us will be like so hard. Well, I better get home. My grandmother will be wondering where I am."

Larkin walked out on the porch with Peggy. As she was about to go down the steps, he clasped her hand. "Thanks, Peggy," he said, then leaned up to her and kissed her lightly and quickly.

Peggy had never been kissed before. She smiled shyly, said nothing, and floated down the sidewalk on a cloud. All the danger, all the problems of persuading Donnie to go with them, even the little painful knot in her stomach disappeared in the warm glow of her first kiss.

CHAPTER 4

An early cold snap had put a chill in the air as Peggy and Larkin walked to school on Monday morning. The cold mirrored what Peggy felt in her heart when she thought about helping Larkin. *I'm scared to death of all this, but I promised to help Larkin, and it's important to keep promises.*

Larkin paused before the main entrance to the school. Students pushed by them, heading for homeroom or the cafeteria to catch up on the latest gossip. A few people nodded and spoke to Peggy as they passed.

"You'll ask Regina about this afternoon?" questioned Larkin.

"Yes. I'm sure she'll come."

"What about Donnie?"

"He's always in the cafeteria in the morning. We can go ask him now." Peggy sighed. *I hate Donnie Himler. I hate having to ask for his help. I dread facing him. He's so conceited. He thinks he's better than everyone else. He'll make fun of me. In front of the whole cafeteria.*

"You don't think he'll join us, do you?" asked Larkin, breaking into her thoughts.

"No. We aren't cool. You're not an athlete, either. I don't think he'll come to your house, and if he does, I doubt he'll believe you."

Larkin nodded. "Let's try."

Donnie sat among a group of his friends, all athletes. They laughed loudly as they horsed around and made suggestive remarks to the girls who passed their table. Peggy liked Donnie even less as she approached the table. When she stopped in front of him, he looked up with just a hint of surprise in his eyes.

Peggy felt her face begin to burn. She wanted to turn and run. The eyes of every boy at the table bore into her. She felt every eye in the cafeteria staring at her. The babble of voices faded and died as she stood looking down at Donnie.

"Hey, Peggy. How you doing?" said Donnie, a sneaky smile playing across his face. "I bet Carla wants to get back with me, right?"

"Not really. Could I talk to you for a minute?"

"Sure. What's up?"

"In private."

"In private? What do you think, guys? Should I trust her?" Donnie laughed and looked around at his buddies. A couple of his friends gave low whistles. A couple sniggered. "Please, Donnie. It's real important," she pleaded, hating herself for pleading to someone she despised. Donnie's eyes had a cool, distant look. *He never seems to care about anyone or anything except himself. He'll never help us. I bet he won't even come to Larkin's house. That would be beneath him.*

"Be back in a minute, guys, unless, of course...." Donnie raised his eyebrows and leered at Peggy. The boys at the table laughed and whistled.

Peggy blushed as she turned and walked quickly away, hoping she wouldn't trip. Donnie followed, strutting like a peacock, nodding to the many people who called his name. Peggy could see a number of heads turn as Donnie joined her in a corner of the cafeteria where Larkin waited.

"You're the new kid in school, aren't you?" inquired Donnie, running his eyes up and down Larkin.

"Yes."

"I thought so. I didn't recognize you. I know most everyone in school. So, Peggy, what's up? You sure Carla doesn't want to get back with me?"

Peggy glared at Donnie. "Trust me. She doesn't. That's not what this is about." *He's so conceited. Wait a minute. Maybe that's how I'll get him to come to Larkin's house. Of course. Appeal to his vanity. I've never known anyone more vain. If I do this right, he won't be able to resist.*

"It's like this," continued Peggy. "Larkin and I need the best athlete in school to help us do something important. No one else is good enough. In fact, Larkin says without you, we'll fail."

"Help you do what?" questioned Donnie, a slight sneer in his voice, as if helping people like Peggy and Larkin was beneath him.

"It's going to take some time to explain," Peggy said nervously. "Could you meet with us after school? It's like really important." Peggy could hear the pleading in her voice again.

"Okay. I guess it won't hurt to hear what you have to say, and we don't have practice today. Where do we meet?"

"Larkin's house. It's close to school."

"Oh, man, I don't know. I thought you were talking about meeting here, but going to Larkin's house...." His voice trailed off.

"Naw. I don't think so. I have better things to do."

"Please, Donnie."

"It's worth twenty dollars if you'll just stop by my house for a few minutes and hear what I have to say," said Larkin quietly.

"Oh, man, you're speaking my language. Give me the twenty and the directions to your place, and I'll be there."

After Donnie went back to his table, a crisp twenty-dollar bill in his pocket, Peggy looked down at Larkin. "Twenty dollars. That's a lot of money. Can you afford that?"

Larkin smiled up shyly. "I'm a weaver."

"You wove that money?"

"Nothing to it."

"But that's illegal."

"No one will ever know. An expert couldn't tell that bill wasn't the real thing."

"That's so cool. I never thought about weaving money. You could be rich."

"That's not why I'm here. I'm here to try to save your world. That's all that matters."

I talked like money has some value. It wouldn't for Larkin. Money shouldn't mean anything to me, either. What good is a bank full of money if the world is destroyed? Stupid to think about money. "I'll make sure Regina comes with us after school."

"Good. See you in English class."

That afternoon, thirty minutes after school ended, Larkin stood in his den. Peggy, Regina, and Donnie sat on the leather sofa. Larkin had just finished explaining to Regina and Donnie who he was and why he had come to Earth.

Regina smiled up at Larkin and hummed a tune.

Donnie's lips curled in a sneer. "You're putting me on, right? You're trying to make a fool out of me?"

Larkin gazed at Donnie, his clear blue eyes boring into the other boy. Peggy could sense Donnie getting uncomfortable under Larkin's steady gaze. She had never seen Donnie look uncomfortable. He was always the one making other people uneasy.

"Come on, Larkin," said Donnie, trying to break the spell of Larkin's eyes. "Admit it. This whole story is a looney toon. Right? You're trying to make a fool of me, aren't you? Because of Carla." He turned and glared at Peggy.

"Let me show you something," said Larkin. "Peggy has seen this,

so there's nothing to be afraid of. Maybe it will help convince you that what I've said is true. I'm going to let this house return to what it was before I wove the improvements."

Peggy watched Donnie as the warm, sunny room turned damp and dark. She saw his eyes get wide. She had never seen that look on Donnie's face before. She saw him blink and his body tense as objects winked out of existence. *He's scared. I didn't think anything could scare him. Maybe he's learning that reality isn't always what it seems. Heck, maybe I'm learning the same thing.*

"Awesome," whispered Regina, her eyes bright. "That's just the awesomest thing I've ever seen."

The atmosphere shimmered, and objects began to wink back into existence. Moments later, the room returned to normal.

"Now do you believe?" asked Larkin, looking at Donnie.

Donnie nodded his head slightly as he stared wide-eyed at Larkin.

Peggy breathed a quiet sigh of relief. *I think Donnie is hooked. Maybe he'll go now.*

"Will you go with us to my uncle's castle?" Larkin asked, glancing from Donnie to Regina and back again.

"I'll go if Peggy goes," said Regina, a smile on her face. "Peggy's my friend. So are you."

"Thanks, Regina. What about you, Donnie?"

"Maybe, but I need to know a lot more about this deal before I decide. How do we get to your uncle's world, and what do we do once we're there? And what's in this for me?"

"I'll weave us to my uncle's world. The trip only takes a few seconds, though it'll be a little uncomfortable."

"What happens when we get to your uncle's world?" asked Donnie sullenly. "What can the four of us do against him if he's as powerful as you say?"

"We'll try to reach my uncle's castle," said Larkin thoughtfully.

"Will we just walk up, knock at the door, and ask him to invite us in?" Donnie's voice grated harshly in the quiet room.

"It won't be that easy. My uncle has created an elaborate defense to keep his enemies away. We'll have to get through that defense before we can face him."

"What kind of defense?" asked Peggy timidly, visions of barbed wire, land mines, and machine guns racing through her mind.

"Four circles of defense surround the castle. Each circle has geographical barriers we'll have to pass, though I don't know

precisely what they are. I've never been to my uncle's planet, and my father never told me."

"Oh, great," jeered Donnie. "You can't tell us what we're facing, but you expect us to go with you anyway. This is stupid."

"Will we have to climb mountains?" asked Regina, her eyes wide.

"Probably. But the physical barriers aren't the toughest part of the defense. In each circle, one of us will face a vision. The vision will touch some part of our lives that we'd rather keep hidden, either a fear we have or a great desire. The vision will seem so real we won't even know it's a vision. Defeating the vision will be the biggest challenge each of us faces. Anyone who doesn't defeat the vision will be locked in it for eternity."

"I don't much like that," declared Donnie. "What else can you tell us about the visions?"

"Not much...just a few things I picked up from my father."

"So tell us," said Peggy impatiently. She wanted to know what she faced, even though the more she heard, the less she wanted to go with Larkin.

"Each of us will step into a vision that seems so real, we won't remember where we are or that we're trying to reach my uncle's castle. The vision will try to trap us–to keep us frozen in an experience that is somehow connected to an essential part of who we are."

I don't like the sound of these visions. I don't like the idea of being trapped by something that takes over my mind and robs me of my freedom. "If we walk into a vision, and we forget everything, how will we escape?" asked Peggy.

Larkin stared at the floor. "I don't know."

"You don't know?" cried Peggy. "Then what chance do we have? We'll end up wandering around a Steven Spielberg set forever, and we won't even know it."

"There's no way I'm getting into something this crazy," exclaimed Donnie.

"But we have to try, don't we?" Larkin pleaded in an anguished voice. "If we don't try, my uncle will destroy your universe, including Earth."

"Maybe and maybe not. But going after your uncle is stupid," declared Donnie. "I mean, if the dude is half as bad as you say, I don't want to be messing around with him. I sure don't want to be messing with these visions. I have better things to do with my life."

"What good will it do to get caught in a vision?" asked Peggy, thinking that Donnie had a good point. "How's that going to change anything here?"

"I'll go, Larkin," announced Regina calmly. "You're my friend. Friends stick together."

"Thanks, Regina. You're my friend, too."

How embarrassing. I should be supporting Larkin. I believe in him. Yet, I've been working against him. Because I'm scared. But friends should stick together. What am I going to do? "I'll go, too," said Peggy, surprised at how calmly she spoke.

"Donnie?" asked Larkin.

"He's scared," Regina whispered to Peggy.

"I'm not scared," snarled Donnie. His eyes shifted, and he cracked his knuckles loudly, first on his left hand, then on his right hand, moving methodically from the little finger to the first finger. "I think this whole thing is crazy, but if you need me as much as you say...I might go—if there's something in it for me." He fingered the twenty-dollar bill Larkin had given him.

"Good," said Larkin, a bright smile breaking across his face. "We have a real chance if you go with us."

How much of a chance? I wonder what my vision will be? How can I escape a vision if I don't know I'm in it? Larkin thinks we have a chance, but it sure seems like we're going to need a lot of luck.

"Could we get hurt?" Regina asked in a small voice that broke slightly as she spoke.

Larkin paused. Peggy saw a dark shadow cross his face. Then it lifted, as if he'd reconsidered what he was proposing and decided that it was, in fact, what he had to do. "What we're about to try is terribly dangerous. We may all die, and if we die on my uncle's planet, we die just the same as if we died in a car accident here. But, if we don't try to defeat my uncle, he'll destroy your world."

"Why choose us?" asked Donnie in a hard voice, even less enthused about going than he had been moments before. "Why not get some adults to go with you? Hey, why not a few good Marines? They'd blow your uncle away in short order. One good nuke would take care of that castle."

"No adult would believe me, and I don't have the power to weave weapons into another dimension. Even if I did, using one of your bombs against my uncle's castle would be like you trying to break into Fort Knox with a water pistol. Force isn't the answer. I

chose you because you're the only ones who have a chance of succeeding. I've sensed a hidden talent in each of you. We have to rely on your special gifts, not on Marines."

"Talents?" Donnie's voice cracked slightly and went up an octave. "What about Regina?" he sneered. "What talent does she have? I mean, get real. She's a retard."

"Don't say that," cried Peggy, glaring at Donnie and daring him to contradict her.

"But it's true," Donnie retorted.

"Wait a minute, you two," Larkin said. "Our whole quest hinges on Regina. That's why I asked her to go with us."

Regina smiled bashfully. "Me?"

"Regina?" said Peggy, surprise flooding her voice. She liked Regina, but she never thought of her as having any special talent. Nor why Larkin wanted her along.

"Yes. Regina. I don't know exactly why or how, but she's essential to our success. I'm not a magician, and I can't see into the future, but success depends on Regina."

"Wow," said Regina, enjoying the attention.

"Suppose I don't want to risk my life on this crazy plan of yours?" Donnie asked in a sharp voice.

"You scared?" asked Peggy, eyes flashing.

Donnie glared at her but didn't speak.

"I can't make you go," answered Larkin simply. "You have to go because you believe it's the right thing to do."

"What happens if we all decide not to go? Will you find someone else?" asked Donnie.

"No one else would have the same chance for success. If you don't join me, I'll go alone. I can't defeat my uncle alone, but maybe I can slow his plans. But your world will eventually be destroyed."

"In my lifetime?" asked Donnie.

"I doubt it."

"So what eventually happens between you and your uncle doesn't really affect me?"

"That's true. If you don't care whether life continues on Earth, then risking your life on this quest is stupid. If all you want to do is live for yourself, then it makes no sense to go with us. But do you have a sister?"

"Yes."

"Does she want to have children?"

"She already has one, and another one on the way."

"Don't you care what happens to them?"

"Of course I do, but...."

"Do you want to have children?"

"I hadn't thought about it. Maybe someday."

"Don't you care what happens to them? Doesn't it matter to you that my uncle will kill them?"

"I hadn't thought about it like that, but why do you care what happens? I don't get it. Why risk your life to save Earth?"

"Peggy asked me the same question, and I'll tell you the same thing I told her. Your world is a unique and beautiful creation. My father considers it the most perfect of all his creations, and he loves it more than all his other creations combined. I've come to love this creation, too. I love everything about it, but especially its music. There's nothing like your music in all the millions of universes created by world weavers. That's why I'm trying to save your universe. If this universe is lost, all that's good and glorious in it will be lost forever. That thought makes me sad."

"How much chance do we have of success?" asked Donnie suddenly. "I'm not sure I'm buying into this, but if I did, what are the odds?" Silence engulfed the room. Three sets of eyes stared at Larkin.

"Maybe one in a hundred."

Peggy's heart sank at his words. *I thought if we went with Larkin, we'd be successful. In the movies, the good guys almost always win. This sounds like we don't have much chance.*

"Even with all your power?" asked Donnie, astonishment in his voice.

"Comparing my power to my uncle's power is like comparing a firecracker to the biggest hydrogen bomb ever built on Earth."

"One chance in a hundred isn't very good," observed Peggy.

"And we only have that chance if we stick together. We all have to believe in what we're doing. We have to give each other complete support. If we can't do that, then our chance of succeeding is almost zero."

"Sort of like the Three Musketeers, huh?" said Peggy suddenly, a little grin on her face.

"What do you mean?" asked Larkin.

"The Musketeers had a motto. *All for one and one for all.* That's how we have to be, right?"

"That's the way it has to be if we want to succeed."

Donnie got up and paced the room. Peggy could tell he didn't know what to do.

"He's afraid," whispered Regina to Peggy.

"Stop saying that," snapped Donnie. "I'm not afraid. I just need to think this through."

"You should be afraid," said Larkin mildly. "I am."

Donnie stopped pacing and stared at Larkin. "You're afraid? With your power?"

"I'm scared silly. My uncle would love to destroy the son of his greatest enemy. Even better, he'd love to capture me and torture me. Of course, he would let my father know about the torture. That would be my uncle's crowning glory."

"Oh, Donnie, make up your mind," cried Peggy. "Either we're going to do this, or we aren't. It's up to you. I thought quarterbacks were able to make quick decisions." *That's mean, but I can't help it. I need to know what he's going to do. If he doesn't go, will I still go with Larkin? Probably. It's a stupid thing to do, but maybe Regina and I can help him.*

Donnie looked surprised at Peggy's outburst. He wasn't used to people talking to him that way. "You think we should go, after what Larkin has told us?"

"We have to go. We can't ignore what's going to happen—even if we won't be around to see Earth destroyed. If you don't go with us, Larkin, Regina, and I will go anyway."

"You're not afraid?" Donnie raised his eyebrows, as if he had assumed all along that Peggy was frightened by what Larkin had told them.

"I'm scared stiff. But if we don't help Larkin, our world dies. I don't want that to happen. Not because some old man on some planet likes to do evil things. That's not right." Peggy stamped her foot impatiently. "So are you in or out?"

"I'm in," Donnie said slowly, as if regretting each word.

Peggy felt her tension evaporate. Much as she disliked Donnie, having him along helped. He was a conceited jerk, but he was strong, and if what she had heard was true, real smart.

"When do we go?" Peggy looked at Larkin as she spoke.

"We could go now."

"I have to tell Mom if we're going to be gone long," said Regina, concern on her face.

"It's 4:30," said Larkin, looking at the clock on the mantle. "We'll be back here by 4:45. I don't think you need to tell your mother."

"Wait a minute," interrupted Donnie. "It's going to take more than fifteen minutes to defeat your uncle."

"We'll be in another dimension—an entirely different time that's not connected to time here. When I bring us back, we'll come back to this very moment—or a few minutes later."

"If we come back," muttered Donnie.

"How long will this take in your dimension?" asked Peggy.

"A few days at least. Perhaps a couple of weeks. It depends on how long it takes us to get through the defensive circles. There's no way to know for sure."

"What about supplies, like food and water? What about sleeping bags and stuff like that?" asked Donnie.

"I have packs for everyone with supplies for at least three weeks. I don't think we'll need more than that."

"Suppose we run out of supplies? Or lose our packs? What then?"

"Let's hope we don't. But if we run short, we'll use our ingenuity. That's what we have brains for."

"Couldn't you just weave food for us?" asked Peggy. "Why even bother with packs in the first place?"

"If I did, my uncle would immediately sense my power. He would find us in minutes. His welcome wouldn't be pleasant."

"Oh, great. So your power is useless on your uncle's planet," groaned Donnie.

Larkin ignored Donnie as he brought out packs stuffed with clothes and freeze-dried food. Each pack had a sleeping bag tied to the bottom. A canteen of water also hung from each pack. A set of sturdy hiking shoes went with each pack.

"We'll have to watch our water closely," said Larkin as he pulled on his hiking shoes. "I don't know how much water will be available. We should plan for the worst and conserve water."

"There sure is a lot you don't know," said Donnie, sarcasm in his voice.

"True." Larkin spoke quietly.

"I'm ready," said Peggy moments later, as she pulled on her pack. "Let's get on with this."

"All for one and one for all," said Regina with a smile.

"Right," agreed Peggy, trying to smile without success.

"We'll stick together, won't we?" Regina spoke directly to Peggy, and there was a slight quaver in her voice that suggested tears.

"You bet."

"Do exactly what I tell you," said Larkin, as he finished adjusting his pack. "Hold hands. Don't let go. If you let go, I'm not sure I can bring you through. When I tell you to, take a deep breath, and don't breathe until we get to my uncle's planet. This will hurt a little, but you'll be okay. Now, take a deep breath and hold it."

Peggy gripped Larkin's hand tightly, glanced around at the soft light filtering into the room, took a deep breath, and closed her eyes. Donnie held Peggy's other hand, and his was sweaty. She felt no sensation of moving, only a heavy pressure on her stomach, as if a large hand was pressing on her, trying to squeeze the air out of her lungs. The hand got heavier and heavier, and Peggy wanted to use her hands to push the pressure away. She wanted to gasp for fresh air. The pressure disappeared abruptly, and Peggy opened her eyes. What she saw made her wish she had never met Larkin, never heard about his uncle, never agreed to leave Newville.

CHAPTER 5

Peggy stood beside the others looking across a parched desert. Shimmering heat waves danced mysteriously along the horizon, occasionally turning into pools of water before dispersing. A bronze sun burned down fiercely, and Peggy felt the rays sucking out her energy, like a vacuum cleaner sucking dirt from a carpet.

I don't think I'm going to like it here–wherever here is.

"Wow," breathed Donnie softly. "I didn't think...I didn't believe...."

"Believe it," declared Larkin, staring up at the sun for a moment. "We're on my uncle's planet. From now on, we're in danger, and we need to be careful."

"It's so hot," murmured Regina, her voice trembling as she spoke. Beads of sweat covered her forehead, and one drop had fallen onto the left lens of her glasses. She held Peggy's hand in a clammy grip.

Peggy gently released Regina's hand. "We'll get out of the heat in a minute. Don't worry." *This heat is unbearable. Not even the hottest day at the beach is this bad. We need to find shade.*

Regina began to hum a tune to herself.

"What do we do?" asked Donnie, still staring around in surprise.

"This is the first circle of defense," explained Larkin. "I didn't have the power to weave us any closer without my uncle knowing we were here. We'll have to cross this desert to the second circle–to those hills over there." He pointed.

Peggy could see low hills that looked like they were covered with trees, with high mountains rising behind. Her heart sank as she stared at the hills. *They're so far away. I can't imagine walking that far. Not with a heavy pack. Not in this sun.*

"That's a long hike," observed Donnie as he shaded his eyes and stared into the distance.

"About twenty miles, I'd guess," said Larkin.

"We're going to hike there in this heat?" asked Peggy in disbelief. *I've never walked five miles at one time, much less twenty. Why was I so impatient to come? Sometimes I'm really dumb. What if I can't make it?*

51

"We don't have much choice," replied Larkin, still looking at the distant hills, then he smiled. "No school buses here."

"What are those?" asked Regina, pointing to the sky.

"Birds," declared Donnie. "Huge birds."

"What kind?" asked Peggy.

"They look like some kind of vulture from the way they're soaring without flapping their wings," said Donnie as he squinted at the black spots. "But I never saw a vulture that big."

"Could they be your uncle's spies?" asked Peggy suspiciously, wondering where they could hide if the birds were looking for them.

"Maybe. I don't know." Larkin looked down at his feet. "I'm afraid there's a lot I don't know about this planet."

"Oh, great. Our guide doesn't know much more than we do," muttered Donnie, trying to sound angry, but revealing more fear than anger in his voice.

"Maybe we should get started and worry about the birds later," suggested Peggy. She wanted to get to the hills and the shade of the trees as quickly as possible.

"Wait a minute. Let's not go crazy here," exclaimed Donnie. "I've seen enough movies about the desert to know we shouldn't go walking about in the middle of the day, especially in this kind of heat. We'd be fried before we got five miles, and those vultures would have a nice meal. We need to find shelter from the sun, maybe from the birds, too. We'll start walking after the sun goes down."

"That makes sense," agreed Larkin. "Let's find cover."

The four travelers spread out in different directions, looking for shade.

"Over here," yelled Donnie a few minutes later. "I've found a dry stream bed with an undercut. There's shade."

They scrambled into the stream bed and huddled against the bank in the shade.

"It's still hot," said Regina. Her face was red and covered with sweat. She kept wiping her forehead with her hand.

"I know it's hot, but we'll be okay here. Try not to move around," said Donnie, who seemed to have taken over as leader. "Save your strength for tonight."

How come Donnie is bossing us around? This is Larkin's quest. Larkin should be giving the orders. I didn't come along to be ordered around by that toad. "Larkin," Peggy whispered, "you should be telling us what to do."

"No," said Larkin quietly. "I'm not good at that sort of thing. We

need a strong, smart person to lead us if we're going to be successful. Donnie has already made one good decision. I probably would have started walking toward the hills, which would have been a disaster."

Peggy didn't say anything else, but she still didn't like Donnie taking over.

"What will we find when we get to the hills?" Donnie asked Larkin.

"I don't know. Each ring of defense will present a difficult barrier, and the closer we get to the castle, the more difficult the barriers will be. But," and Larkin paused thoughtfully, "the visions will be the most difficult barriers we face."

"Can we help each other when one of us is caught in a vision?" inquired Peggy.

"I don't know."

"The blind leading the blind," muttered Donnie, a frown on his face.

The four sat quietly, each wrapped in thoughts about the quest ahead. The heat left them tired and sleepy. A low rumble—like far-off thunder on a hot night—soothed them and seemed to suggest that they close their eyes and sleep. Peggy felt her eyelids drooping, just the way they did in history class after lunch when the room was warm and the murmur of the teacher's voice seemed to say *sleep, sleep, sleep.*

"Get out of here," screamed Donnie suddenly as he jumped up and started pushing and shoving while grabbing packs and flinging them out of the stream bed. Donnie yanked Peggy to her feet and shoved her toward a cut that led up to the desert floor. "Run!" he yelled as the rumble increased, threatening to drown out his voice.

They charged up the cut, feet skidding on loose rocks and pebbles, Donnie pushing and yelling from behind. As they flung themselves out of the stream bed, a wall of raging brown water roared by, filling the stream bed to the rim.

"That was close," said Peggy, still shaking with fear. "I've heard about flash floods. I even saw one in a Disney movie, but I never thought I'd see one in person."

"It almost got us, didn't it?" stammered Regina. Regina gripped Peggy's hand, and Peggy could feel her shaking, too.

"Did your uncle do that?" Donnie demanded as he glared at Larkin. "Does he already know we're here?"

Larkin knit his brow in thought. "I don't think my uncle knows we're here, or that he created the flash flood. I'm pretty sure this was

just a freak of nature. Thanks, Donnie. If you hadn't acted so quickly, we'd all be dead."

Regina began to hum a little tune, but her eyes remained wide with fear.

"It's okay, Regina," said Peggy. *I'm going to have to look out for Regina. I'm scared, but Regina is petrified. I don't blame her. We've only just started, too. I dread the rest of the journey.*

"The sun's almost down. I think we should start walking," said Donnie as he surveyed the sky. "I don't see any vultures, either."

"How long will it take us to reach the hills?" asked Peggy.

Donnie stared at the distant hills, now turning a deep blue as the sun sank behind them. "If it's twenty miles, and if we don't get delayed, we should get to those hills before morning."

"I wish we were already there," murmured Peggy.

"We'll be delayed," remarked Larkin. "One of us will be drawn into a vision. Let's hope the vision doesn't delay us too long. We don't want to get caught in the open when the sun comes up."

"Let's get going," urged Peggy as she swung her pack onto her back. "We'll never get there if we stand here talking."

Sweat quickly soaked the four travelers as they hiked across the blasted floor, which radiated the heat of the day. No one spoke for the first hour as Donnie led them across the parched land. The western sky darkened to a deep purple, and a few stars began to twinkle. Peggy reached for her canteen.

"Not yet," said Donnie. "We better conserve our water. We don't know how long this will take or when we'll find more water. I'll tell you when to drink."

Peggy grimaced. Her mouth felt like it was stuffed with cotton balls. *I want a big drink, and I want it now. What I wouldn't give for the cold pitcher of water in Grandma's refrigerator. I never appreciated that water pitcher until now, when I most want it but can't have it.*

"Could we rest?" asked Peggy, breathing heavily from the exertion. Donnie had been leading them at a fast walk, and her legs ached.

Donnie stopped walking. "We'll take a ten-minute break every hour. I think that's what they do in the Army. We'll take a drink at our next break. That'll give us something to shoot for."

"Can't we have a little drink now?" pleaded Peggy.

"No. You'll need it more later."

"How far have we come?" asked Peggy, not wanting to think

about water, knowing that the more she thought about it, the more she would want to empty her canteen.

"I'm not sure," replied Donnie. "We've moved well. You girls haven't slowed us down as much as I thought you would. I'd say we've covered four or five miles."

"That's great," said Peggy, ignoring his comment about girls slowing them down. "By our next break, we'll be half way there."

"If we can keep the pace up," remarked Donnie, looking at Regina as if he didn't think she was capable of that.

The second hour dragged by as thirst and fatigue took its toll. Their pace slowed. Peggy's throat felt as dry as the desert she walked on. Her back ached from the weight of her pack, and the pack straps cut into her shoulders. *Can I make twenty miles? Four was okay, but this is terrible. Can I hold out until the next break? Then what? Can I go any farther? I can hear Donnie sneering at me now.*

When Donnie called the next break, they all collapsed, like rag dolls suddenly dropped to the ground–all, that is, except Donnie, who looked like he could continue walking if it hadn't been for the others.

"Two mouthfuls of water. No more," said Donnie.

Peggy rolled the first gulp of water around in her mouth, wishing she had gallons more to splash over her tired, dirty body. She swallowed a little at a time, washing away the cotton balls in her mouth, making the water last as long as she could. Never had a single mouthful of water tasted so good, seemed so precious. *What I wouldn't give to be at the Newville swimming pool getting ready to dive in. Wouldn't that feel sensational. I wonder if I'll ever see that pool again. Such beautiful blue water. I wonder if I'll ever see Newville again. Or Grandma. Stop thinking such thoughts. Not good to think that way. Larkin said we had a chance, and I trust him.*

As the night wore on, Peggy stumbled along in a deepening nightmare. She had never known such fatigue, such pain. Her pack straps burned into her flesh. Her legs screamed for rest. As Peggy struggled up a small rise strewn with boulders, she stumbled and fell. Regina collapsed beside her.

"We have to rest," croaked Larkin. "Even if we don't make it to the hills by sunrise."

"Okay," Donnie said hoarsely. "Two mouthfuls of water."

"How far have we come?" asked Peggy after drinking her first mouthful of water. She would save the second mouthful. Knowing

she could drink it whenever she pleased gave her a good feeling.

"Over half way, I think," said Donnie.

"Can we get to the hills by morning?"

"We must."

Peggy stared up at the sky with its strange stars. A warm breeze blew fitfully, and she shivered. The next thing she knew, Donnie was shaking her awake. "What?" she said crossly, having momentarily forgotten where she was.

"We have to go."

The nightmare returned. "How long have I been asleep?"

"An hour. We all needed it."

Regina hummed a tune as she struggled awkwardly with her pack. Donnie allowed them one swallow of water before they set off.

As Donnie stepped forward to lead them into the darkness, a number of things happened in quick succession. A brilliant flash of light exploded in front of Donnie, as if his foot had tripped the switch of a huge floodlight. Peggy blinked and recoiled, knocking over Regina, who knocked over Larkin.

Bright orange spots filled Peggy's eyes. *Have I lost my sight? Please, not that. Anything but that. Could this be my vision? Going blind?* Peggy struggled to her feet, relieved that her sight quickly returned. She found herself staring at what appeared to be a giant, brightly lit stage. Donnie stood at the center of the stage, staring off to his left.

"What happened?" asked Regina, blinking though her thick glasses and looking at Larkin for an explanation.

"Donnie's in his vision."

"What do we do?" asked Peggy.

"I don't know, yet. Let's see what happens. Maybe Donnie can get out on his own."

"What if he can't?" asked Peggy.

"He'll be trapped for eternity."

"And us?"

"We'll have to go on without him—unless you want me to take you home." Larkin's lips twisted in anguish.

Peggy didn't reply to the question of going home. She stared at Donnie, who stood on a rough field with patches of brown grass. An old, two-story, weather-beaten house loomed forlornly in the background. Peggy could see Donnie's breath coming from his mouth in white puffs. He shivered. A large man with a beach ball belly lumbered up to Donnie. Salt-and-pepper hair hung over his

ears. A scraggly beard—three or four day's growth—covered his face. Small, pig eyes peered out from under bushy eyebrows. The man carried a football.

"All right, boy, let's git to work."

"I'm really tired, Pap. We had a long, hard practice today, and I've got lots of school work to do."

"School work? What you be talkin' about school work fer? You gonna make big money playing pro ball. You ain't gonna make any money doin' school work, boy. So don't be givin' me no lip, you hear? We got work to do if you goin' to be the best. Ain't nobody goin' to give you nothin' lessen you work fer it. You hear me, boy?"

"I know, Pap. But just tonight. I'm really beat. If I don't get my homework done, I won't pass. I have to pass, Pap. I have to graduate."

"You'll pass. They ain't not gonna pass the best athlete in the history of that there school. You gonna go to the university, and then you gonna play pro ball and make us lots of money. Now git started. Fifty jumpin' jacks. Now." His father cuffed Donnie roughly across the back of the neck.

Peggy could see the pain in Donnie's face as he did the jumping jacks and the dozen other exercises his father ordered in quick succession. He gave Donnie no break between exercises.

"Last one, boy. Twenty-five push-ups."

Peggy watched Donnie struggle, saw his arms quiver like jello, heard his breath explode from his lungs after each push-up.

"We gonna have to start workin' harder, boy," growled his father. "You ain't in no condition to play pro football, that's fer sure. Now let's work on your passin'. I want them scouts from them big colleges to really see something at the game Saturday. Your brother will run the routes."

Another boy appeared, one who looked much like Donnie, only a year or two younger. After each pass, Donnie's father would yell and curse at Donnie, screaming what he'd done wrong.

"I'm doing my best, Pap," cried Donnie in frustration at one point.

"That ain't nowheres good enough, boy. You got to do better if you gonna play pro ball. Now concentrate, or do I have to whup you upside the head to git your attention?"

Donnie's brother ran a pass route again, and Donnie threw a perfect spiral. His brother caught the pass without breaking stride.

That's a beautiful pass. I don't know much about football, but that's got to be about as perfect a pass as anyone can throw.

Pap, who was only a step away from Donnie, leaned forward and cracked Donnie across the head. Peggy heard the hand hit, saw the pain flash across Donnie's face, saw the tears start in his eyes. "You got to loft the ball more, boy. Don't give the defensive back any chance to git it. What you got an arm for, boy. Use it," bellowed Pap, his eyes narrowing to slits of anger.

"I'm trying, Pap."

"Try harder. We gonna stay out here 'til you git it right."

"Larkin, we have to do something," cried Peggy. "I can't stand this."

"I don't know what to do, Peggy," replied Larkin in an anguished voice.

"This is horrible. There must be something we can do."

"Look, Peggy. Something is happening."

The stage before them began to go all fuzzy, as if someone had slowly rotated a camera lens out of focus. For a moment, the stage was just a misty yellow light. When the mist cleared, Peggy saw a football stadium filled with cheering people. On the field, two football teams faced each other. Pap stomped along the sidelines yelling at Donnie, who quarterbacked one team.

"You got to do it now, boy. Ain't no more time left. This is your big chance, boy. Show 'em boy. Show 'em."

"What's he mean, Larkin?" asked Peggy.

"Look at the scoreboard."

The scoreboard showed ten seconds left in the game and Donnie's team behind by three points. A touchdown would win the game.

Donnie took the snap and faded back as his receivers raced down field. Donnie lofted the ball toward one of his receivers near the end zone. It seemed to Peggy that a bright spotlight followed the flight of the ball as it spiraled down the field toward the swiftly running receiver. Just before the ball arrived, the defensive player nudged the receiver off stride, and the ball fell just beyond his fingertips. A hush fell over the stadium. Then Peggy heard the booming voice of Donnie's father.

"You sorry excuse for a football player. You're worthless. You're a failure. You're nothin' but whale crap, and that's the lowest thing there is 'cause it's at the bottom of the sea. I'm ashamed, I am. "

"But it wasn't his fault," Peggy screamed at the vision. "The receiver was pushed. The pass was perfect. Donnie's father has to see that, doesn't he?"

Larkin said nothing as he stared at the vision.

The football team, which had been milling about the field, turned as one, like a flock of birds that wheel simultaneously in the air, and walked away, leaving Donnie standing alone on the field. Loud boos drifted down from the stands.

Tears streamed down Donnie's face as he looked toward his father. "I did my best. It's only a football game."

"Your whole future was riding on this game, boy. Your best ain't good enough. I'm ashamed of you."

"I'll work harder, Pap. Honest. I won't ever complain about extra practice."

"Too late now, boy. You blew it. You had the opportunity to make an impression, and you blew it. Them scouts won't be back. Worthless. That's what you are, worthless."

"But next year, Pap. I can do better next year."

"You lost this year. You're a loser. Everyone knows that now. Never amount to nothin'. Maybe your brother be the one. You ain't. Nothin' but a loser," sneered Pap as he turned and walked away.

"I'm not a loser. I'm not!" cried Donnie. "I'll work harder."

The stage went all fuzzy again. When it cleared, Donnie stood on the same rough field with the patches of brown grass that Peggy had seen at the beginning of the vision. An old, two-story, weather-beaten house loomed forlornly in the background. Peggy could see Donnie's breath coming from his mouth in white puffs. He shivered a little.

A large man with a beach ball belly lumbered up to Donnie. His salt-and-pepper hair hung over his ears. A scraggly beard–three or four day's growth–covered his face. Small, pig eyes peered out from under bushy eyebrows. The man carried a football.

"All right, boy, let's git to work."

"It's going to repeat again, just like a continuous loop tape, isn't it?" Peggy asked in horrified fascination.

"I think so," said Larkin, glaring at the vision. "I didn't know that's how these visions worked. Forever repeating. For eternity. For Donnie, it's his fear of failure and fear of letting his father down."

"Did what we see already happen?"

"Part of it. Where we see Donnie practicing with his father and brother probably did happen. The big game is Donnie's greatest fear.

That game hasn't happened yet. Donnie is terrified that he might fail if everything is riding on one pass."

"I don't know why he should care what his father thinks," Peggy declared. "There ought to be a law against people like him having children." She clenched her fists. She forgot her fatigue. She forgot her fear. All she wanted to do was help Donnie. "Can we go into his vision to help him?"

"It might be dangerous to go into someone else's vision. We might get lost in Donnie's vision."

Donnie was once again doing exercises under the fierce eyes of Pap. Peggy saw even greater pain in Donnie's eyes than the first time he did the exercises. Then another truth hit her. "Larkin, don't you see? The pain keeps building. Each time this scene repeats, Donnie suffers a little more than the time before."

"My uncle thought of everything, didn't he," said Larkin, angry and frustrated over what he saw and his inability to do anything about it. If he used his power, his uncle would know. They'd be prisoners in seconds.

"Well, I'm not going to sit here and watch this any longer," cried Peggy. "All for one and one for all." Without further thought, Peggy ran forward. Three steps later, she found herself in Donnie's vision.

CHAPTER 6

Peggy stood a few feet from where Donnie lay on the ground doing sit-ups. She could hear his rasping breath as he forced himself up, could see the pain in his face, could see the veins bulging in his neck.

"Stop it, Donnie. You don't have to do this," screamed Peggy. "This isn't real. It's the vision Larkin told us about."

"Peggy? What are you doing here?" gasped Donnie, staring at her in surprise.

"Don't you remember? We're on a quest with Larkin and Regina to save Earth. You've been caught in a vision."

"Vision?" He stared at her as if she were talking in a foreign language.

"Remember Larkin? Regina? Our trip to another dimension?" *How do I get him to remember?*

"What you doin' here," bellowed Pap, looming over Peggy, his pig eyes flashing. "My boy's got work to do. He don't need no little girlie to distract him. Now git on your way."

"I have to talk to Donnie. It's important." Peggy stamped her foot, trying to hide her fear. "And I'm not a little girlie," she added angrily. *I'm not going to let him scare me. I have to make Donnie remember or everything is lost.*

"Don't you tell me what's important," bellowed Pap. "I know what's important. Now git your little fanny out of here before I throw you out."

Fear swept through Peggy like fire through a dry pine forest. *What happens if Pap throws me off this field? Where will I end up? I could be lost forever.* "I have to talk with Donnie," Peggy said fiercely, glaring up at Pap.

"Why, you little brat. I'll teach you to interfere with my boy," growled Pap, raising his hand to strike. Peggy stood her ground and defiantly looked into his eyes. Pap took a mighty swing.

"No!" yelled Donnie and leaped at his father.

Peggy flinched, waiting for the pain of the blow–but she felt nothing. She opened her eyes to find herself in the darkness of the

desert with Donnie standing beside her. Donnie looked blankly at Peggy. "What happened to Pap? Why is it dark? Where are we?"

"You were in a vision," said Larkin, as he and Regina dashed up. "Don't you remember?"

Donnie looked around before speaking in a choked whisper. "I'm beginning to. It was so real, especially the game."

"Was the vision something that happened to you?" asked Larkin.

"No. I've never been in a game like that. The practices in the field behind my house happened many times."

"How awful," said Peggy.

"I try not to think about those practices."

"No wonder," said Larkin. "They must have changed you, huh?"

"I guess. When I was growing up, Pap always said I was soft and weak—that I'd never amount to anything unless I worked on my game all the time, so I could go to the NFL and make lots of money. That's all he ever talked about—making money in the NFL and having fancy cars and a mansion. He said I couldn't afford to have any feelings about people—that people would just use me. Pap said I had to look out for number one."

"So he beat that lesson into you," said Peggy quietly.

"I guess he did. Any time I showed any interest in books or in people, he'd whip me with a belt. He said it was for my own good."

"So your dad beat all the best feelings out of you," said Larkin, a frown on his face.

"At the time, I thought he was right, even if it did hurt. Now, I'm not so sure."

"You okay?" asked Peggy, looking sympathetically into Donnie's eyes, for the first time beginning to understand his actions at school.

"I'll be okay. Thanks for coming after me. I couldn't have taken the pain much longer. I don't know what would have happened if you hadn't stepped in. That took guts."

"I couldn't stand watching what was happening to you."

"Why did the vision end?" asked Donnie, turning to Larkin.

"I think you broke the vision when you stopped your father from hitting Peggy. Somehow, when you tried to protect Peggy from the blow, you broke through a wall that you've been living with. So the vision ended."

"What was the wall?"

"Maybe," said Peggy slowly, thinking hard about the vision, "the wall was your inability to care about other people's feelings."

"You mean I only thought about myself?"

"Something like that."

Donnie nodded slowly, his eyes on the ground. "We've also learned something important about the visions," he said. "We can enter each other's visions, so we can help each other, just like Peggy helped me. We also know that breaking out of a vision means breaking through some hang-up we each have."

Larkin nodded. "Next time we'll be better prepared."

"Hadn't we better get moving," said Peggy, though she hated the thought of walking anymore that night. Every cell in her body ached and cried out for rest. *Oh, how I'd love to be back home in a hot bubble bath. I'd be all clean instead of covered with dirt and sweat. I wouldn't have to walk anywhere except to my room, where I could cuddle down in soft, clean sheets.* Peggy shivered at the thought. Had Larkin offered to take her home right then, she might have accepted.

"Peggy's right. We don't want to get caught out in the open when the sun rises," said Larkin. "I think everyone should have a little water before we start."

"That sounds good, but only one swallow," said Donnie, taking charge again.

Regina hummed a little tune as she stood next to Peggy. "What are you humming, Regina?" Peggy asked.

"Mozart. The second movement from his twenty-third piano concerto."

"It's pretty. Where did you learn it?"

"The radio. I listen to music all the time."

"Do you only listen to classical music?"

"No. I listen to all kinds, but I like classical the best. I don't tell people, though. They'd laugh at me."

"And you remember the melodies?"

"I remember every melody I hear," replied Regina. "I must have thousands in my head by now."

"That's amazing. How do you do it?"

"I don't know. I just never forget music I hear. When I hum, I hear every note of the music in my head, just like I was listening to the radio."

"You hum a lot, don't you?"

"Humming makes me feel better, especially when I'm afraid. Like now. I'm afraid Peggy. All this scares me, and I don't see how I can help, either. I'm so sore, I don't know how I'm going to walk all the

miles ahead of us. I feel like I'm just holding everyone up and getting in the way."

"I'm afraid, too, Regina. But remember, Larkin said you were the most important person on this quest, and he knows. You just keep humming and stick close to me. We'll be okay." Peggy spoke confidently to Regina, even though she didn't feel certain that everything would be okay.

"We better get going," announced Donnie. "The night is passing, and I think we need to get to those hills before the sun gets very high in the sky—or we may not get there at all. Those vultures we saw yesterday worry me. I don't think we want them to see us, and we're getting close to where they were flying."

They trudged off into the darkness, Donnie leading and Larkin in the rear. They hadn't walked far before a faint light dawned in the east. Morning approached, and they forced their weary legs to move faster.

Without warning, Donnie dropped to the ground, motioning the others to do the same. Moments later, after peering into the gloom before him, he slowly turned on his belly and crawled back to the other three, who huddled next to a boulder.

"A vulture," whispered Donnie. "It's huge. Twice my size. It's sitting on a rock. I can't tell if it's asleep or not, but we better detour around him. I have a bad feeling about those birds."

No one disagreed, so they crawled wearily away from the bird before resuming their march. Fatigue and thirst tortured them. Even Donnie began to show the effects of the hike. His shoulders slumped, and his breathing became more labored.

An hour later, Peggy crumpled to the ground, and the column halted. "I have to take a break," she croaked through parched lips. She took her canteen and gulped the last of her water.

"Ten minutes," said Donnie as he stared at the red sun creeping over the eastern horizon. "We don't have much farther to go."

"How far?" asked Regina.

"A couple of miles, I think. Not far. An easy walk after what we've already done." Donnie sounded confident.

Even knowing she only faced two more miles, Peggy didn't know if she could make it. Every part of her cried out in pain—every muscle pleaded for rest. She wanted to sleep. She didn't care about anything—vultures, evil uncles, or Earth. Regina slumped beside Peggy.

"You girls okay?" asked Donnie. Peggy was too exhausted to be

surprised at his concern for them, which was not like Donnie at all.

Regina stopped humming. "I can't go any farther," she whispered.

"Come on, Regina, don't wimp out on us now. You've done fine so far. You can make another two miles."

Tears appeared in Regina's eyes. "I can't walk any farther."

"Why not?" asked Donnie and Larkin at the same time.

"My foot. I have a blister on my heel."

"Let me look," said Larkin. After removing her boot, he peeled Regina's sock back and peered at the wound. A large blister had broken, and the back of her right heel was raw and bleeding. Larkin took some salve out of his pack and dressed the wound.

"How bad is it?" asked Donnie.

"It's bad. She can't walk until the salve takes effect."

"How long will that take?" asked Peggy.

"Four or five hours at least. The salve is good, but it takes time to work."

"Couldn't you weave it back to normal?" asked Donnie.

"I could, but my uncle would know I was here. We'd be prisoners in his castle in less time than it takes to think about it."

"Okay." Donnie turned back to Regina. "Let's go, Regina. I'm going to carry you."

"You can't do that," said Peggy, wondering why Donnie would even suggest it. "You'll never make it."

"I have to try. If we leave Regina here, she'll die from the heat or the vultures. If we all stay with her, we'll all die. Now stop talking and get going. Get under the trees. I'll get there as soon as I can."

Donnie went over to Regina and got her onto his back, carrying her piggyback. Peggy could see the strain in Donnie's face, could hear him grunt as he started walking, could see his legs quiver and buckle under the weight of his load.

"Let's go," commanded Larkin, picking up Donnie's pack and walking off at a brisk pace. He knew that Donnie was correct and that the success of their quest hinged on whether he could carry Regina to the shelter of the woods. If Donnie didn't make it to the woods, all would be lost, their attempt to save Earth over before it had begun. He tried not to think about that, or what he would do.

"Will he make it?" Peggy asked after they left Donnie and Regina behind.

"He has to. We need them both if we're going to succeed."

Peggy, who moments before didn't think she could walk another ten feet, moved quickly at Larkin's side, carrying Regina's pack. The pain in her legs had not eased, but seeing what Donnie was attempting gave her a burst of energy. She vowed to make the tree line before she sat down again.

An hour later, Larkin and Peggy sat in the cool shade of a grove of trees, but their eyes stared into the desert looking for Donnie. A second hour passed before Donnie stumbled under the trees, collapsing to the ground the moment he set Regina down. Donnie's eyes had been swept clean of all emotion. "Water," he gasped thickly.

Peggy took his canteen and held it to his lips. Donnie emptied the canteen, nodded to Peggy, and fell asleep.

"Let me see your foot," said Larkin to Regina, who sat quietly humming a tune.

"How is it?" asked Peggy.

"It looks better already. The salve is working. She'll be able to walk soon. It may hurt a little, but not too badly."

"We've gotten through the first circle. That's pretty good, isn't it?" Peggy spoke as Larkin put more salve on Regina's heel.

"Yes, but we've got three more circles to go, and each will be more difficult to pass than the one before. We also have three more visions to face. That worries me most."

"I wonder what mine will be?"

"Something you don't expect. It'll catch you off guard, most likely. Now, I think we better get some sleep."

Peggy couldn't go right off to sleep, though fatigue made her muscles quiver uncontrollably. She lay on her back, staring up into the large trees that loomed over them. They looked like oak trees, only much larger. The leaves, twice the size of a normal oak leaf, were more blue than green. No sunbeams penetrated to the forest floor through the thick canopy of leaves. She glanced into the forest. It looked as gloomy and forbidding as a dark, musty cellar. The trees seemed to bend low and interlock their branches, as if trying to tell strangers to keep out. When Peggy drifted off to sleep, it was a sleep of bad dreams where she had to walk great distances without water or rest. When she woke from her uneasy, unrefreshing sleep, it was mid-day. Larkin sat staring into the forest.

"Do we go that way?" asked Peggy.

"Yes. But this is an evil forest, and we'll need to be careful in there. This forest will try to keep us from getting through."

"At least we can travel by daylight now. That's a help."

"If you call this daylight. It's more like early evening. We need to stick close together. It would be easy to get separated, and I don't think the trees would let us get back together."

The thought of wandering alone in the grim forest made Peggy shudder. *What a scary thought—to wander alone in this forest. I can almost hear the trees laughing at me. I need to make sure Regina stays close to me, and I'll stick close to Donnie. I think I'd rather walk another day in the desert than enter these woods.*

Donnie stirred. "What time is it?" he asked in a tired voice.

"About noon, I think," answered Peggy.

"We should get moving."

"Right. But you needed sleep, and Regina needed to rest her heel. Larkin's salve has helped. She'll be able to walk now."

"Good." Donnie grinned weakly. "I don't think I could carry her again—at least not today. How's our water?"

"I have half a canteen," answered Larkin. "Regina has about the same. You and Peggy are empty. I think we should split what we have and drink it now. Then we'll find more, even if we have to go out of our way to get it." No one disagreed with Larkin's suggestion.

"Let's eat something first. I'm hungry," said Regina.

"I'm hungry, too," said Donnie. "What have we got, Larkin?"

"Dried fruit. We don't have water to mix up the freeze-dried packets."

The four sat silently in a circle eating dried apricots. None of them had eaten since lunch of the previous day. A depressing quiet surrounded them. They could see the desert shining brightly under the hot sun, but the interior of the forest looked even gloomier than before—a world of mysteriously shifting shadows that might hide—what? No one wanted to get up and push on, partly because of fatigue, but partly because the forest seemed a cruel, evil place, where danger lurked behind every tree.

"We have to go," sighed Peggy, her voice sounding flat in the gloom.

"My legs don't want to move," said Donnie. "I think the forest is telling me to stay here."

Regina began to hum a melody, and the sound was like a small shaft of light penetrating the thick cloud of leaves over their heads. The forest had never heard such a sound before. The trees seemed to draw back, and the forest seemed less impenetrable, less intimidating.

"That helps, Regina," said Larkin, and he began to hum along with her. Peggy and Donnie began to hum. The four travelers got to their feet, slung their packs over their shoulders, and started into the woods.

"I feel like I'm in *Hansel and Gretel*," murmured Peggy. "I just hope we don't run into the evil witch."

"Any idea which way we should go?" Donnie asked Larkin as they trudged into the deepening gloom.

"Up. My uncle's castle is at the top of the mountains beyond these hills. My father told me that."

The four friends continued to hum, and for a short time, they made good time, which buoyed their spirits. The land sloped gently upwards, and walking was easy.

Before long, the trees began to close in, as if they now understood that the gentle music would do them no harm. Limbs drooped and slapped at their faces. The travelers slowed, then stopped. Before them lay a deep cut in the ground, as if, ages ago, a giant plowshare had cut a furrow through the forest. The cut lay directly across their path.

"It's almost like the forest is trying to prevent us from going in the direction we want," mused Donnie.

"My uncle wants this forest to keep strangers away from his castle," said Larkin.

"What do we do now?" asked Peggy, not liking the idea of going down into the deep cut, which was even more dark and forbidding than the forest they had been walking through.

"We have to get across this cut. We can't let it push us away from the castle. We need water, too," added Larkin.

"There might be water at the bottom of this cut. It would be a natural spot for water to flow," said Donnie, peering down into the gloom.

"Well, let's decide and get on with it," said Peggy impatiently. "I want to get out of these woods before night. I don't like them."

"Me either," murmured Regina, as she looked around at the brooding forest that walled them in.

"I say down. What do you think, Larkin?" Donnie looked at Larkin.

"I agree."

The four scrambled down the side of the cut, slipping and sliding on slick leaves that carpeted the ground. Briars tore at clothes, hands,

and faces. Rocks hidden under leaves, and roots snaking out from trees, tripped them.

They halted at the bottom of the cut. Larkin had a bright-red scar across one cheek where a thorn had slashed him. Both of Donnie's hands had blood on them. Regina wore a red earring of blood.

"It's damp down here," said Donnie. "There ought to be water somewhere around here."

They moved slowly. There were fewer trees at the bottom of the cut, but the undergrowth was thicker, and the spongy ground made walking difficult. "There," yelled Larkin, pointing to the right as he scrambled to a small pool of clear water lying between moss-covered rocks.

"Don't muddy it," said Donnie. "Give me your canteens."

Donnie carefully filled each canteen to the brim as clear water continued to bubble into the pool. Then Donnie passed his canteen around and everyone drank their fill.

"That tastes so good," sighed Peggy. The cool water had refreshed each of them.

"Now let's see if we can get out of this place," said Donnie after refilling his canteen.

Climbing out of the cut was more difficult than climbing down. The damp leaves were slippery as ice. The travelers stumbled and fell, often knocking down the person behind. Larkin banged his knee and tore his pants. Regina fell heavily on her elbow and ripped her jacket. Mud covered Peggy's hands. The climb wore everyone out.

"I hope we don't run into many obstacles like this," said Donnie, breathing hard from the exertion. "We'll never get through these woods."

The forest, dark and morose at mid-day, had turned even more sullen and forbidding as the day ran quickly toward night. "We better find a place to camp," said Donnie. "We don't want to be walking about these woods at night."

Peggy groaned. She hated the thought of spending the night in the woods, but she knew Donnie was right.

They found a small hollow where two trees had blown down, forming a protected pocket. Clearing away twigs and limbs took only a moment, and Donnie had a fire lit shortly after. Spirits rose as the flames danced skyward, casting shadows on the large trees towering over the camp. Donnie and Larkin prepared a hot meal of rice and chicken from their freeze-dried stores. The food disappeared quickly.

"We need to keep watch," said Donnie, as they rested beside the fire with pleasantly full stomachs and with the knowledge they didn't have to walk anymore that day.

"What for?" asked Regina, who had been humming quietly to herself.

"I don't trust these woods. There's something evil here. Maybe the evil will leave us alone. Maybe not. I think we should be prepared, just in case. We also need to keep the fire going during the night in case any wild animals are around. I'll take the first watch and go as long as I can to give the rest of you as much sleep as possible. Then Regina, Peggy, and Larkin. If you feel like you're falling asleep, wake the next person up."

Wind moaned through the trees as Peggy tried to sleep. Her body cried out for sleep, but her legs kept cramping, and her mind kept turning over everything that had happened so far on the trip. *I don't know what I expected, but it wasn't this. Would I have come had I known? What kind of vision will I have to face? How will I handle it? Will I be able to break the vision? If I don't, then what? Will I spend an eternity in a dream—but not knowing it's a dream? A living vegetable. Could there be anything worse?* After much tossing and turning, Peggy drifted into a fitful sleep.

"Time for your watch," whispered Regina, shaking Peggy lightly.

Peggy heard the voice from a great distance, and she wanted to ignore it. She didn't want to wake up. She had just gotten to sleep. She felt like she was climbing out of a deep well as she woke up. "Already?" she murmured sleepily. Her body felt stiff and sore when she moved. She shivered as she got out of her sleeping bag. The damp night air depressed her, and she wanted to crawl back into her warm sleeping bag and forget everything.

Regina shuffled to her sleeping bag.

"You hear or see anything?" Peggy asked.

"I don't think so. It's so dark, and the fire makes funny shadows. Twice I thought I saw eyes in the woods, but I wasn't sure."

"Okay. Get some sleep."

Peggy piled more wood on the fire so it flared up brightly. Donnie and Larkin slept soundly. Peggy warmed herself by the fire, trying to drive away the chill that made her shiver uncontrollably. The fire crackled, and little sparks rose up toward the overhanging trees, winking out before they got to the lower boughs. But the fire's warmth made Peggy want to sleep. She felt her eyes get heavy, but she fought her desire to sleep. She got up and walked around the

campsite, but fatigue and cold brought her back to the fire. *I wish I were home in a nice hot bath. That would feel great. It would be a school night with lots of snow falling outside. I could go to bed late and know that I could sleep in next morning. Warm bed. Clean. Soft. Comfortable. Nothing to worry about. No fear. Just warmth....*

Peggy jerked awake, aware that she had been sleeping. The fire burned low, and she scrambled to pile on wood. The forest had lightened, and a gray mist hung among the trees. Early morning had arrived, but she heard no birds announcing a new day. Her three companions slept soundly. She shivered. *What will the others think? I can't believe I went to sleep. Suppose a wild animal had come along? We could have been killed. How could I have failed so miserably? Will the others ever trust me again? I've got to do better in the future. Thank goodness nothing happened. No sense waking Larkin now. I can't sleep anymore. I wonder what this day will bring?*

"You didn't call me for my watch," exclaimed Larkin when he woke.

Donnie jerked awake at Larkin's voice. "What happened, Peggy?" asked Donnie, concern in his voice.

"I fell asleep," she replied, staring at the ground as she kicked a leaf. "I'm sorry."

"Okay," said Donnie quietly, as he looked into the forest. "Things like that happen. But as we get closer to the castle, we'll all have to be more careful. From now on, two people should be on watch at all times, just in case."

I can't believe he didn't yell at me or call me a stupid girl. I expected that. Why didn't he make fun of me—embarrass me in front of the others?

"I'm hungry," said Regina as she shrugged off her sleeping bag.

"Me too," chimed in Larkin. "We better have a good meal. We won't have time to fix anything during the day."

The forest remained somber and forbidding. Through a small break in the canopy, the travelers could see dark clouds piling up, clouds heavy with rain. Peggy shuddered at the thought of rain. *I hate being wet and cold, and that's what I'm going to be today. This is going to be worse than yesterday.*

"There's a poncho in each pack," said Larkin. "We better put them on."

As they prepared to break camp, the rain came, heavy and cold, and the wind rose, thrashing the trees about. Spirits that had risen with the hot breakfast, soon dropped to new lows as they stood

huddled about the hissing remains of the campfire. No one felt like talking. Even Regina did not hum.

"We have to push on," Donnie said.

"Then let's get on with it," said Peggy. The rain, driven by the wind, had already begun to find ways to get under the poncho she wore, and she was beginning to shiver.

They walked with heads bowed against the rain, which swept fiercely down the hill. Each step required complete concentration. Every couple of feet, one of them would slip or fall.

I thought nothing could be worse than the desert. Wrong again. Yesterday, we didn't have enough water. Today, we have too much water. I was burning up yesterday. Today, I'm cold and miserable. I'd love to see a warm sun. I wonder which is worse, the heat or the cold? Probably the one you have too much of.

"Where are we going?" Peggy yelled to Donnie.

"I don't know, but we need shelter. What do you think, Larkin?"

"Shelter sounds good if we can find it," said Larkin. "We can't make much headway in this storm."

The forest offered nothing in the way of protection as they searched for relief from the howling wind.

"This is like a hurricane," yelled Donnie.

"Let's keep moving until we find cover," cried Peggy, and stepped forward, heading up the hill. She felt a slight tingle race through her body, almost like a shiver that had caught her unawares.

Peggy's mother and father, seated on a large sofa in front of a crackling fire, looked up and smiled as Peggy entered the room. For the briefest moment, Peggy thought that she had forgotten something important, something she had promised herself not to forget.

CHAPTER 7

"Hello, dear. Finished your homework?" asked Peggy's mother, her warm smile radiating love for her daughter.

"Yes," replied Peggy. "It was easy tonight." *What was I supposed to remember? Was it something I was supposed to tell Mom? No. I don't think so. Was I supposed to call Kristi or Carla? No. Not that. I hate it when I forget stuff I've promised myself to remember. It was something that made me feel sad. What could it have been?*

"Come sit with Dad and me. We were just going to have some hot chocolate. Would you like some?"

"Sure." Peggy flopped down beside her father as her mother went to make the hot chocolate. *Why am I so tired? I can't remember doing anything that would make me this tired. I feel like an old woman. Golly, I'm losing my memory, and my body is giving out, too. I'll never make it to twenty-one at this rate.*

The fire crackled merrily, and the heat felt wonderful. She had felt like an ice cube when she first entered the room. The fire made her feel peaceful, just the way her cat, Miss Tibbs, must feel when she stretched out in front of the fire. Peggy watched the snow falling outside. A large drift had piled up against one window. She shivered with pleasure at being so warm and cozy and snuggled up to her father.

"How's my girl doing?" Her father gave her a short, quick squeeze of affection.

"Okay. But I've forgotten something important, and I can't remember it to save my life. Does that ever happen to you?"

"All the time, sweetheart, though it seems to happen more and more as I get older." He grinned and chuckled softly.

"Oh, well, I guess I'll remember it if I stop trying so hard."

"Probably. How's school going?"

"Okay. I love my math class. Geometry is so interesting–so logical. I love working out the problems, and Mr. Kline is a terrific teacher."

"That's good. Are there any boys in your class that you like?"

"Oh, Dad...."

"Well, you're growing up and getting very pretty. If I were a boy, I'd sure be interested."

"Dads always say things like that." Peggy smiled up at her father, who had kept his arm around her. *I love it when Dad holds me close. I have to be one of the luckiest people in the world. So why do I feel like something is wrong? Dad mentioned boys, and I almost remembered. It's something about a boy I like, but I can't remember the boy. Something isn't quite right, but I can't figure it out. I feel so...strange.*

"Hot chocolate," announced her mother, as she entered the room carrying a tray with three steaming mugs. Each mug had tiny marshmallows swimming in the hot chocolate. Peggy loved marshmallows in her hot chocolate.

"Peggy, your dad and I have been talking about Christmas," said her mother after taking a sip from her cup. "We have something special in mind."

Christmas? There's that strange feeling again that something isn't right. "Well? Don't keep me in suspense, Mom."

"We thought we'd do something extra special this year." Her mother smiled over at her father, and Peggy saw her wink.

"And?" Peggy knew her parents were stretching out the announcement as long as possible, making her suffer in anticipation.

"We've decided to take you to the Caribbean for your Christmas gift this year."

"The Caribbean. Wow. That's like so fantastic. I can't believe it. Where?"

"Cancun, Mexico," said her father. "We leave the day after Christmas. You may miss a few days of school in January, but we didn't think you'd mind. Of course, if you'd rather not miss school, you could stay with your grandmother while your mother and I are gone."

"Dad," squealed Peggy. "This is so cool." *I can't believe I'm going to Mexico. I'll come back with a great tan. My friends will be so envious. But wait. Dad mentioned Grandma. Why did that make me sad? Why did that make me think I've forgotten something important? These thoughts are all so confusing...but Mexico will be great. My gosh, to lie on a beach all day will be super.*

"Oh, there's one other thing, sweetheart," said her father. "You can bring a friend along."

"Awesome. Who should I ask?"

"What about the boy you always walk to school with?" her father asked, a twinkle in his eye. "You two spend a lot of time together."

"Why not, dear?" added her mother. "Larkin is such a nice young man. We'd be delighted to have him with us."

Peggy froze. *Larkin. I need to remember something about him. That's what I've been trying to remember. But what? It's something more important than going to Mexico. Something is wrong. Very wrong. But what?* Peggy looked around the room for anything out of place, but everything seemed perfect.

"Why, Donnie, what are you doing here?" asked Peggy's mother. "I didn't hear you knock. I'm glad you let yourself in."

Donnie Himler stood in the doorway to the family room. He was covered with snow that was fast melting in the warmth of the room. "Peggy?" he said quietly.

"Hi, Donnie." Donnie's appearance confused Peggy. *Why would Donnie Himler barge into our house on a night like this? He doesn't live close to us, and besides, I hate Donnie Himler. I'm sure he doesn't like me, either. Yet...I don't hate him as much as I thought I did. Looking at him there, I almost like him. How can that be? What a crazy evening.*

"Could I speak to Peggy for a minute—in private?"

"No need to talk in private, son," said Peggy's father. "We have no secrets in this family."

"I'd really like to say something to her privately, sir, if you don't mind?"

"But I do mind," replied Peggy's father.

Peggy heard a hard edge to her father's voice that surprised her. *What's going on? Why would Dad talk that way? He's almost angry. Donnie just wanted to talk in private. What's the big deal?*

"Peggy," said Donnie as he turned to her. "Don't you remember what we're doing?"

Peggy shook her head, though something tugged at the corner of her mind. *This has something to do with what I didn't want to forget.*

"Larkin asked us to help him save Earth. He took us to his uncle's planet. That's where we are now."

"I guess I sort of remember. But, isn't that all over now?"

"Yes, darling, it's all over now," whispered her mother in a soothing voice. "Don't even think about such nonsense anymore. You're home now."

"You better be going now, son. I don't like you disturbing my daughter," said Peggy's father.

"Think, Peggy," pleaded Donnie. "Try to remember. You're caught in a vision. You've got to break the vision."

"Get out of my home," growled Peggy's father suddenly, as he rose and strode menacingly toward Donnie.

"Peggy, this is all a dream. The vision is trying to trap you. Your parents are dead," yelled Donnie as he backed out the door.

"I just don't understand some children today," muttered Peggy's father, as he returned to the couch. "He was talking such nonsense. I better speak to his mother. He can't go around barging into homes and disturbing people like that."

Peggy didn't hear a word her father spoke. *Parents dead? Yes! They were dead. This is all a charade, but I don't want this charade to end. I want to keep these parents who make hot chocolate and take me to Mexico over Christmas. What difference would it make if I stayed here? Who would be hurt?*

Larkin. He'd care. And Regina and Donnie. They'd care. And...Earth. Something about Earth. Something important. I can't remember what, exactly, but if I stay here, something bad will happen to Earth. I have a responsibility.

Peggy rose slowly from the couch, tears in her eyes.

"What's the matter, sweetheart?" asked her mother in a soothing voice. "Did Donnie upset you?"

"You aren't real," replied Peggy in a choked voice. "I can't stay here. I have work to do."

"Don't be silly, little girl. Of course we're real," said her father. "You come back, drink your hot chocolate, and relax. You've been working too hard at school. You're just a little nervous."

"I have to go," said Peggy, and she walked out the door into a cold rainstorm where her three companions waited for her.

"You did it, Peggy. You did it," shouted Donnie as he hugged her.

"I did?"

"You broke your vision," said Larkin, also hugging her and kissing her on the cheek. "We weren't sure you could—or would. It must have been terribly difficult."

Peggy's memory returned quickly, and regret flooded her body as she thought about her parents in the vision. Tears welled in her eyes. She missed her parents worse than she'd ever missed anything in her life. "I couldn't have broken the vision without Donnie's help. Everything I wanted most was in that vision," she added wistfully.

The rain hid the tears that flowed down Peggy's face as she talked to her three friends, not that it mattered to Peggy if anyone saw her crying. All she could think about was the warmth of the room, the love of her parents, and her desire to return to them.

"Two visions down, two to go," said Donnie grimly. "Let's hope we're as lucky with the next two."

"You okay, Peggy?" asked Larkin, staring up into her face as he held her hand.

"I'll be okay. I'm surprised Donnie came after me, though."

"I was going to come for you, but Donnie thought he should do it. He said he owed you one."

"He was unselfish to take a risk he could have avoided."

"I think," Larkin said quietly, "that he may have joined the musketeers."

"I hope so. You were right. We need him."

"Maybe more than I even thought."

"Okay," said Peggy loudly, "let's get moving. We still have a long way to go." She knew they couldn't stand around and waste time while she recovered from her vision. *Will I ever recover from that vision? I've never felt so low in my life. Even though I never knew my parents, the vision seemed so real, as if I had actually lived with them. Everything was so right. I'll never forget the pain—or the regret—of walking out of that room.* The regret lodged in her stomach like a great, cold stone.

Peggy walked over to Donnie, who was looking up the mountain, not that he could see much in the gloomy mists that shrouded everything. "Thanks."

Donnie smiled crookedly. "That's okay. You helped me out."

"The vision hurts, doesn't it?"

"It's the worst thing I've ever gone through."

"Me, too."

The forest had turned a dismal gray-black. The rain came down steadily. Mists hid the thick canopy overhead. Each step forward was an adventure on the slick leaves and moss. Even Donnie could not keep from stumbling and falling on occasion. Their pace slowed to a crawl as they fought their way up the mountain. In the distance, Peggy heard what sounded like dogs baying, though the sound chilled her soul. The travelers stopped and listened.

"What's that?" stammered Regina.

"I don't know," answered Peggy, putting her arm around the other girl and pulling her close.

"Scary sound."

"Wolves, I think," said Larkin. "Coming this way."

"What do we do?" asked Regina, eyes wide with fright.

"If they're after us, we need a fire," cried Donnie.

"We better work fast," said Larkin.

"This is going to be tough," said Donnie, looking around as he took command of the situation. "Peggy. Get small twigs and dry leaves. Look close to tree trunks and under fallen branches. Larkin, Regina. Find larger limbs to burn–dry stuff that's off the ground if possible. Hurry."

The chilling howls echoed dully through the gray mist. Donnie found a small open area and cleared a circle. Using the twigs and leaves that Peggy brought, Donnie soon had a small fire sputtering to life. It would flame up, then die in the dampness. Donnie blew gently on the tinder, talking to the fire, encouraging it, protecting the flames from the rain with his body. Finally, the flame held, and Donnie added larger tinder. Regina and Larkin returned with armloads of dead branches. Donnie piled them on the fire carefully as he continued to blow on the flames. The branches soon burned brightly in spite of the wind and rain.

The howling drew closer. Regina grabbed Peggy's hand and stood next to her, shivering with fear.

"Regina," yelled Donnie. "Sing a song–a happy song."

"I can't," stammered Regina. "I'm too scared."

"Yes, sing," cried Larkin. "I don't think evil things will like a happy song."

Regina began to sing "Climb Every Mountain" from *The Sound of Music.* Her voice wavered as she started, then steadied and got stronger.

"That's it," cheered Donnie. "Keep singing. The louder the better."

Suddenly, Regina stopped singing. The forest had gone deathly still.

"What's the matter?" asked Peggy.

"Look," said Larkin, and pointed into the trees.

All about them, fierce yellow eyes glowed in the shadows. Great, hulking wolves surrounded them. Dozens of the huge beasts circled the blazing fire.

"Sing, Regina," ordered Larkin.

Regina closed her eyes and began again, and the wavering melody seemed to intimidate the evil beasts which stalked them.

"What do we do when the fire burns down?" whispered Peggy to Donnie.

"I don't know."

"We don't have much of a chance, do we?"

"Not much, unless Larkin has something up his sleeve."

Larkin stood quietly watching the beasts. He seemed completely unafraid.

"Can you use your power?" asked Peggy, as she edged over to Larkin.

"These beasts are beyond my powers. If there had been just one or two, yes. But when they attack, there will be too many for me to deal with."

The wolves closed in as the fire burned lower. Peggy could see their great, yellow fangs and lolling tongues. Bloodthirsty eyes glared at the travelers. The beasts snarled and snapped as they circled closer.

"Take a burning piece of wood," ordered Donnie as he passed out sturdy limbs with ends that flamed brightly. "When they attack, hit them in the face. Now we all have to sing. A song of joy and triumph—as if we've already won. You start, Regina."

Regina caught Donnie's enthusiasm. "Okay, we'll sing "Age of Aquarius." Anyone know it?"

"I do," said Peggy. She knew it from the oldies radio station.

Regina began to sing, her voice loud and strong. Peggy joined in. Normally, she felt embarrassed about singing, and would never consider singing in public. Not this time. Donnie and Larkin soon joined in, though they didn't know many of the words.

"Yes, this is good," yelled Larkin. "Louder."

The woods rang with the four voices lifted in song. The wolves seemed unsure of their quarry now and stood panting, staring at the four singers as if uncertain what to do next. A few backed away. Never before had they faced a quarry that sang like this and seemed unafraid. Suddenly, a great black beast leaped at Donnie with a roar. Donnie jammed his flaming brand into the wolf's mouth and quickly stepped aside. The beast screamed in agony as it fell to the ground. Other wolves advanced slowly, licking their chops, but aware that one of their leaders had fallen.

"We won't last long," muttered Larkin.

"Stand close together. Use the branches as clubs if you have to," said Donnie, unwilling to give up even when defeat seemed inevitable.

Two wolves ran forward and leaped. Peggy stuck her branch out with both hands, closed her eyes, and waited for the massive bodies to slam into her. Nothing happened. She opened her eyes. Before her

she saw the two beasts sprawled on the ground, arrows protruding from their sides. Other wolves lay scattered about, all with arrows in them. The rest of the pack fled into the woods.

"What happened?" whispered Peggy.

"I don't know," answered Larkin. "I was just going to try to weave us all home when...."

"Could you have done it without us holding hands?" asked Peggy.

"I don't know," replied Larkin, looking into the depths of the forest.

From the mist, Peggy saw people begin to emerge—little people who looked almost like leprechauns. They carried bows and quivers of arrows. They were dressed in forest colors, greens and blues and browns. Heavy beards covered their faces, and from under shaggy eyebrows, Peggy saw clear blue eyes.

"Who are you?" asked Larkin when more than two dozen of the little people had drawn close about them in a circle. The tallest of them only came up to Larkin's chin.

"We were just about to ask you the same question," said one, who seemed to be the leader of the band.

"We're travelers," replied Larkin, "on a quest. We mean no one any harm. We were attacked by the wolves and might be dead if you hadn't saved us. We owe you many thanks."

"We usually mind our own business and leave others to their own devices," said the leader, looking into Larkin's eyes. "But we were drawn here by your song. We've never heard anything like it in all our days. Nothing in our legends speaks of such singing. We also loath the evil wolves."

"Thank you," stammered Peggy. "You saved our lives."

The little man seemed to look at each traveler in turn, as if considering what to do. "You've thanked us twice, and such courtesy deserves reward. You're wet and tired, so you shall go with us to our shelter and spend the night where it is warm, dry, and safe. We also have food." With that, he smiled and waved them to follow.

None of the weary travelers had the will or the energy to resist, and since the little man and his followers seemed to mean them no harm, they willingly followed as he led them at an easy pace up the mountain. Peggy was aware that members of the little band slipped quietly through the trees on all sides of them, guarding against a return of the wolves. They traveled less than a mile before they came

to a great fall of rocks that cascaded down a thousand feet from the top of the mountain. Peggy looked up the rock fall, hoping she wouldn't have to climb it.

"Wait here," said the leader. "I must check with our leader before I bring strangers to our lodging."

Peggy huddled next to a large boulder with her three friends. The wet, cold weather had saturated them all, and they shivered in quiet misery. Even Regina didn't hum.

"What do you think?" asked Donnie, shivering as he spoke.

"Good people," replied Larkin.

"We can trust them?"

"Yes. Without them, we'd be dead."

The little man returned with a smile on his face, his blue eyes twinkling. "Come with me," he said gently. He led them into a maze of rocks where they worked their way toward the summit. An occasional guard would peek from behind a rock as they passed.

Peggy groaned. Her legs didn't want to obey her commands. She could feel her muscles quiver, like shaking jello. Climbing among the boulders was almost more than she could manage. She knew she would never reach the summit. Just as Peggy was ready to say she could go no farther, they came to a small tunnel. Their guide slipped through easily. Donnie barely squeezed through, and Regina and Peggy had to stoop over and scrunch up. Only Larkin passed through easily.

The tunnel opened into a large cave filled with torches, crackling fires, tables filled with food, and dozens of the little people moving about. Peggy saw many women and children. Some of the children stopped their play to gawk at the strangers. A few pointed and said things to their playmates. Some laughed. She saw adults scold children when they laughed at the strangers.

"Follow me," said their guide, who led them to a large chair in front of a roaring fire. On the chair sat an old man with white hair and a bushy white beard. Wrinkles covered his face, but the same clear, blue eyes Peggy had seen in their guide and his men peered out at the travelers. Peggy took an immediate liking to the old man. There was an aura of wisdom and kindness about him. He motioned the travelers to take seats on the furs scattered about.

"I am Shu, leader of this clan. We," and the old man nodded toward the people in the cave, "are the Jenfu, a race almost as ancient as this planet." The old man smiled, and his eyes twinkled as he

looked at Larkin. "And you, my boy, are a world weaver, not yet come into his power, but one of great potential if you live."

"How did you know I was a world weaver?" exclaimed an astonished Larkin.

"I have lived all my life in the presence of Gurnacht, the evil world weaver who lives on this planet. I well know the aura of a world weaver. But you are different, I think. You are not like Gurnacht, though within you there is a seed, if watered, which might destroy the good."

"I could never be like Gurnacht," stated Larkin solemnly.

"You may think not, but the potential is there. We all have potential for evil. Even you. Nothing created is completely good or completely evil. Remember that. The Jenfu are examples of that.

"Gurnacht wove us for his pleasure, to use for sport. In the beginning, we were an evil people, always fighting, waging war on each other, bent on destruction. Gurnacht enjoyed watching us war on each other. But ages ago, Gurnacht forgot us and left us alone, as he has done with other things on this planet. We grew as a people, not in stature, mind you," and Shu smiled, "but we have seen that war and evil leads to nothing but sorrow and regret. Now we do good when we can, fight only that which is evil, and hope, someday, to see the end of Gurnacht's rule. Then we will come out of our caves and live in peace. That is our great desire."

"Maybe that will happen," said Larkin.

"We hope. Now, tell me how you come here. This is most unusual. An event such as this has never been recorded in our histories or our legends."

"As you guessed, I'm an apprentice weaver," began Larkin. "My father is Gurnacht's brother, a man who weaves good."

"Ah, yes. Our legends speak of him—the weaver of love."

"Gurnacht is now weaving a universe that will destroy the universe from which my friends come, and perhaps destroy all that my father and the other world weavers have created over the ages. The four of us are going to Gurnacht's castle to stop him."

The old man said nothing for some minutes as he examined the four travelers. "That's a great undertaking, my friends. What do you plan on doing if you safely reach the castle?"

Larkin dropped his head. "I don't know for sure. I hope I'll know what to do once I get there."

"You are either very brave or very foolish. Gurnacht is powerful

beyond all imagination. I fear for you, my friends. But great endeavors should be applauded, and though I hold out little hope for you, my people will sing your praises and help you as we can. But now, you need to get into dry clothes and eat warm food. After that, I think, we will decide what you should do next." He turned to a group of men standing near his chair. "Arnue, show our guests to their quarters."

Arnue had led the band that saved them from the wolves. He showed them two small sleeping areas where the travelers were able to change into clean, dry clothes from their packs. Peggy wanted to lie right down on the thick animal skins and go to sleep, but gnawing hunger forced her to the communal tables piled high with food. Shu waited for them by the long tables.

"We have prepared a banquet in honor of our new friends and in honor of the men who slew many wolves today. We do not often catch so many wolves unawares, and it is a great victory for our people." Shu escorted the four travelers to seats beside him at the head of the table.

The table was much too small for all but Larkin, but a few adjustments made it possible for the three larger travelers to eat in comfort. The Jenfu had loaded the tables with bread, both white and dark, and thick butter, fruits and nuts, milk and honey, and heaping bowls of mushrooms. Steaming bowls of vegetables completed the meal.

"This is wonderful, Shu," said Peggy, as she chewed a piece of rich, dark bread covered with butter and honey. "I was starved."

The four travelers inhaled huge quantities of food as their hosts marveled. The Jenfu had never seen hungry teenagers eat before, and they were astonished. Donnie, especially, was the object of much conversation and many stares as he kept refilling his plate. A few of the Jenfu made friendly wagers on how much food Donnie would eat.

There was much coming and going of the little people as they cleared empty platters from the table and placed more food in front of the guests. Every now and then, a group of the Jenfu would break into song. The eating and singing lasted for more than three hours. The travelers said little, content to eat and listen to the music.

When everyone had eaten their fill, Shu rose and beckoned the travelers to follow him to a small chamber, where they sat comfortably on skins as they talked.

"You are determined to go to Gurnacht's castle?" asked Shu seriously.

"That's our plan," replied Larkin. "Only in the castle, where we can confront Gurnacht, do we have a chance of defeating him."

"But you say that you don't know how you will defeat him."

"I hope when the time comes, I'll know what to do."

"You go into great danger, my friends," said Shu, sadly shaking his head. "I think I shall not see you again once you leave us. Gurnacht is mighty beyond words."

"I know his power," said Larkin, "but this is something I must do, and my friends have agreed to help. We know the danger."

"It is a mighty undertaking, and one worthy of song." Shu smiled kindly, though his eyes revealed sadness. "I think the minstrels are already making songs about you and about the amount of food you consumed. I hope other songs about you will have as happy an ending. But, now, for tomorrow. We can guide you to the Stairway to Darkness. Our legends tell us that at the top of the Stairway to Darkness, you will find more mountains to climb, and on the peak of the highest mountain, a lake. In the middle of the lake is Gurnacht's castle."

"This knowledge will help us," said Larkin. "If we're successful, we'll come back and have a grand celebration with the Jenfu."

"I hope that may be so. But now, before you sleep, my people have a request. The men who saved you cannot stop talking about the marvelous singing they heard just before they rescued you from the wolves. We love music, and my people want to know if you would sing a song or two for us? We would be most grateful."

Larkin, Peggy, and Donnie all turned and looked questioningly at Regina, who blushed and dropped her head.

"Will you sing?" asked Peggy gently.

"I guess so. If they want me to."

"Regina is our singer and knows hundreds of songs," explained Larkin.

"Wonderful," exclaimed Shu, obviously pleased that he would hear the singing his men had praised so highly. "Come. My people wait."

Moments later, Regina stood before the assembled Jenfu in the silent cave. "What shall I sing?" Regina asked Peggy.

"Anything you want. Perhaps something quiet since we're about to sleep."

Regina thought for a moment, then began to sing an old Irish song, "Danny Boy." Her voice wavered off pitch as she started, but then grew firm, and her clear notes filled the cave. The Jenfu sat before Regina entranced. One song only whetted the appetites of the Jenfu, and more songs followed. For almost an hour, Regina sang, before Shu called a halt.

"We could listen for the rest of the night, but we know that you have suffered much today and have hard travels before you tomorrow. It is time you rested. Thank you. You have given us great joy. We have never heard anything so beautiful. Perhaps you will come again and teach some of our musicians."

The weary travelers flung themselves on their skins, but sleep did not come immediately.

"What great luck that the Jenfu found us," mused Larkin.

"We wouldn't have made it without them," said Donnie. "Those wolves would have polished us off in short order."

"This may be that little extra help we need to complete our mission," said Larkin.

"Let's hope," agreed Donnie. "I wish the Jenfu were going the rest of the way with us."

"Shu said the Jenfu won't climb the Stairway to Darkness. Their legends say it means death to do so."

"Too bad. I'd like to have a couple of their bowmen with us."

"They liked me, didn't they, Peggy," said Regina when the conversation died down.

"They loved you, Regina."

"It didn't matter that I'm different."

"It didn't matter a bit."

"Singing for them felt good. I'd like to come back and sing for them again."

The four friends fell into a deep sleep, glad for the safety and the comfort the Jenfu had supplied. Had they known what the Stairway to Darkness would bring, they might not have slept so soundly.

CHAPTER 8

Peggy had barely drifted off to sleep—or so it seemed—when she felt a gentle hand on her shoulder. Shu peered down at her with his bright eyes. "Morning approaches. You must be off quickly if you want to reach the Stairway to Darkness before nightfall."

Peggy groaned. She felt like she had run a marathon. Every muscle hurt, and the warmth of the skins held her like a magnet. She didn't want to face the chill morning air. She didn't want to hike all day. She wanted to sleep.

"Come on, Peggy," called Regina, who was already up and dressed. "Time to go." Regina began to sing a song to herself.

Shu, who was leaving their sleeping area, stopped and listened to Regina. "That's beautiful," he murmured.

"The Jenfu sure like your singing," said Peggy, who yawned.

The four travelers met by the banquet tables where a simple breakfast of fruit, bread and butter, honey, and milk was set out.

"I didn't want to get up," moaned Donnie sleepily.

"Me either," sighed Peggy. "But we might as well get this over with. We can sleep later."

"Let's hope," said Donnie, a frown playing across his face.

They ate their breakfast in silence. Peggy felt a gloomy hand press down on her. All she wanted to do was crawl back under her warm sleeping skins. Only in sleep could she forget the danger they faced. Forget how tired she was. Forget how sore she was.

"You must leave now, my friends," announced Shu. "I would rather ask you to stay, for I know you go toward danger. A group of my people will guide you to the Stairway to Darkness. You'll be safe today, I think."

Each of the travelers felt that staying with Shu would have been preferable to going off in search of Gurnacht. Even Larkin felt a tug to delay their journey another day. He liked Shu. He wanted to sit and listen to the legends of the Jenfu. But Gurnacht was weaving Earth's destruction. Maybe, if they defeated Gurnacht, he would come back and enjoy the company of the Jenfu. He smiled.

Arnue, their guide from the day before, appeared. "I'll be your

guide. Perhaps as we walk, you will sing," he said, speaking to Regina, who blushed and stared at the ground.

A somber, gray day greeted the travelers, though the rain had stopped. "We'll make good time," said Arnue, as he surveyed the landscape and the sky with the practiced eye of an expert woodsman. "It won't rain today, though the sun won't shine. With luck, we should reach the Stairway to Darkness an hour before nightfall."

"Will you spend the night with us?" asked Larkin.

"Shu thinks that would be wise."

Peggy breathed a sigh of relief. She didn't like the idea of spending the night alone at the foot of the Stairway to Darkness. Not with wolves on the prowl.

"How far is the Stairway?" asked Donnie.

"About a ten-hour walk," replied Arnue. "We'll cross two mountains, but they're not high, nothing like the Stairway to Darkness, or the mountains beyond. My men will scout all around us as we march, so wolves or other evil beasts will not surprise us."

Arnue led the way, with Peggy at his side. Regina, Larkin, and Donnie followed in single file. Two Jenfu brought up the rear. Occasionally, Peggy saw Jenfu slipping along like shadows in the woods on their right and left.

"Why is it called the Stairway to Darkness?" asked Peggy.

"Ages ago," began Arnue, "when we were the playthings of Gurnacht, he would force individual Jenfu to climb the Stairway to Darkness."

"How could he do that if a Jenfu didn't want to?" interrupted Peggy.

"Gurnacht said he would kill family or friends if a person he chose to climb the Stairway to Darkness didn't obey. Our legends tell of a few Jenfu who refused his orders. Gurnacht destroyed their entire families and all their relatives, no matter how distant. Gurnacht has terrible power, and he's completely evil.

"Sometimes, when a Jenfu climbed the Stairway to Darkness, great storms would buffet the cliff, and people would fall to their deaths. Legend has it that Gurnacht actually wove storms to kill those on the cliff. Many died before they reached the top. Those who made it to the top never returned. Legend says they were taken to Gurnacht's castle and tortured for his pleasure, but we don't know for sure. So the cliff became known as the Stairway to Darkness."

Arnue's words did not reassure Peggy. The thought of having to

climb the Stairway to Darkness was a cold lump of expanding fear in her mind.

The travelers and their escort moved at an easy pace. Less than thirty minutes into the march, Peggy heard the blood-curdling howl of a wolf. The sound brought back dark memories of the previous day, and she shivered.

"Are the wolves after us?" asked Larkin.

"I don't think so," said Arnue, though he hesitated as he spoke, and looked into the woods, as if trying to read the mind of the wolf that howled.

A second howl echoed dimly through the forest, and Arnue increased his pace. Though Arnue was a foot shorter than Peggy, she had trouble keeping up with him. A Jenfu warrior glided out of the shadows and said a few words to Arnue, who looked worried. Arnue stopped under a massive oak tree and gathered the travelers next to the trunk.

"Having wolves out so early in the day is most unusual. There are many on the prowl, though we've heard only two howls. Our scouts have also spotted many vultures in the sky."

"Do the vultures spy for Gurnacht?" asked Larkin.

"We think so, though we're not certain. Gurnacht may have forgotten them like he's forgotten us. The vultures may simply be following their evil instincts, which are to hunt and kill Jenfu, or those who look like Jenfu," he concluded pointedly.

"So it's better that they don't see us," said Donnie. "If they do spy for Gurnacht, they might alert him to a party moving to the Stairway to Darkness."

"That's true," agreed Arnue. "How important is it that you get to the Stairway to Darkness today?"

Larkin glanced at his fellow travelers as he answered. "It's not critical. We want to get on with our task, but one day lost won't affect the outcome."

"Good," said Arnue. "We should get back to the cave as quickly as possible."

Arnue started off at a trot, with Peggy, Donnie, Larkin, and Regina strung out behind. They moved swiftly for ten minutes when Peggy heard a scream.

Arnue whipped around, his face filled with anguish, and dashed back down the trail they had been hurrying along. Donnie and Larkin followed, with Peggy on their heels. She heard the scream again.

Regina. How could I have let Regina lag so far behind? Why didn't I think about her? Why didn't I stay with her? I was scared. I worried about myself and no one else. If anything happens to Regina, I'll never forgive myself. I told her I'd stick with her and I didn't. Some friend I am.

Seconds later, they dashed into an open area. Regina stood with her back against a small elm tree. Before her hopped three large vultures, their great yellow beaks open, sharp teeth flashing in the dull, morning light. Red eyes glowed like coals of fire, and their black heads darted at Regina, like cobras measuring their prey. One vulture closed in—intent on snapping Regina's neck with his mighty beak.

Arnue gave a loud cry, pulled his sword, and rushed between Regina and the fearsome birds. "Back," he bellowed and swung his sword at the nearest vulture. The birds seemed momentarily surprised by Arnue and hopped back a few paces, hissing loudly. Their surprise didn't last. Angered that someone would deny them their prey, especially a Jenfu, who they were bred to hunt, the massive birds closed in.

Arnue raised his blade and stepped toward the nearest bird, who was four times Arnue's size. The bird darted its beak at Arnue, attempting to grab Arnue by the neck. Arnue slashed at his attacker, catching the end of the beak with his sword. The bird screeched in pain, and flapped a few feet away.

Regina sank into a whimpering heap behind Arnue. She closed her eyes, put her hands over her ears, and turned her face away from the battle in front of her. The two remaining birds warily closed on Arnue.

"He doesn't have a chance against them," cried Peggy. "We have to do something."

"We don't have any weapons," yelled Donnie, looking wildly around. "What can we do? Where are the other Jenfu?"

"They went ahead to scout for wolves," replied Larkin.

"Larkin! Use your power," screamed Peggy. As Peggy spoke, one bird grabbed Arnue by the shoulder and flung him into the air. Arnue tumbled head-over-heels through the air before crashing to the ground. He still gripped his sword as he groggily rose to his knees. His left arm hung limply at his side.

"I can't use my power."

"You can't let Arnue die," cried Peggy, tears streaming down her face. "Clubs, Donnie. We need clubs." Peggy and Donnie looked wildly for branches to use as clubs, but they found nothing.

A bird closed on Arnue, who weakly swung his sword at the frightful beak. The bird barely flinched as it drove its beak into Arnue, who fell to the ground. The beak stabbed down on Arnue again. Arnue flinched, then lay still. The other bird turned toward Regina, who lay whimpering at the foot of the tree.

"Oh, no," wailed Peggy as she watched the bird hop towards Regina.

Suddenly, the twang of bows sounded in the still air, and arrows sped across the clearing, finding their marks in the three birds. The birds screamed and flapped away–too late. More arrows flashed through the air, silver missiles of death, and the vultures crashed to the ground.

Peggy rushed to Arnue, who lay quietly on the damp ground. His face had already turned a sickly yellow. "Arnue?" cried Peggy, as she cradled his small head. There was no response, not even the flutter of an eyelid.

"He's dead," said one of the Jenfu archers who had rushed to help Arnue.

"Dead?"

"Come. You can do nothing." He helped Peggy up and pushed her to where the others stood.

"How can he be dead?" asked Peggy. "I liked Arnue so much."

"We must go quickly," said a Jenfu warrior. "There's a large pack of wolves near, greater than any we've ever seen before, and more are coming. We've kept them at bay, but only at great cost." He glanced back at Arnue's body, which two warriors carried. "We can't fight so many wolves in the open."

"Come on, Peggy," said Larkin as he grabbed her hand and pulled her forward. "We have to hurry."

"Leave me alone," she cried, avoiding his eyes. *I'll hurry, but not because Larkin wants me to. He could have saved Arnue, but he didn't. He just stood there and watched. Arnue saved his life–all our lives–and Larkin wouldn't lift a finger to save him. What kind of beast is Larkin anyway? I thought I knew Larkin.*

The travelers dashed through the forest, pursued by a chorus of howls. The Jenfu warriors closed in tight about the four travelers.

"Faster," yelled their new guide.

Peggy gritted her teeth and plunged on. Her breath came in short gasps. *No way am I going to let a wolf get me now, not until I have it out with Larkin. Then I'll never speak to the creep again.*

The howling broke over them like a great wave crashing on the ocean shore. Wolves filled the forest on all sides. Archers stopped, turned, and fired arrows at the black shadows darting among the trees. Peggy didn't have time to see if the arrows found their mark.

Suddenly, she was shoved roughly through the tunnel into the Jenfu cave. Warriors pushed a large boulder over the entrance, effectively blocking any wolf from entering. Shu and other Jenfu waited for the weary travelers as they entered the cave. Peggy saw concerned faces break into smiles when husbands and brothers and sons appeared unharmed. She saw one woman with a mouth twisted in anguish—Arnue's wife. Peggy couldn't imagine the pain and sorrow the woman must feel. Peggy felt her own hot wrath build as she remembered how Larkin refused to help Arnue.

"This has been an evil day," Shu said. "You must rest now. After we bury our dead, we will eat and talk."

The four travelers sat in the small room where they had slept the night before. No one spoke for some time. Regina didn't hum as she cleaned her glasses. Donnie wrapped his arms around his legs and stared at the floor, lost in thought. Peggy glared at Larkin, who sat quietly with his eyes closed, his forehead creased in a frown.

How could Larkin be so callous? Only yesterday, Arnue saved us from the wolves. Didn't Arnue deserve to be saved? How could Larkin be such a selfish pig? I thought Larkin was just about the best person I'd ever met. I liked him better than any boy I've ever known. Not now. I don't want to have anything to do with him ever again. "How could you?" Peggy finally demanded in an anguished voice. "Arnue saved your life. He deserved to live."

"I know," said Larkin in a hollow voice, his head bowed.

"You could have saved him."

"I know."

"Then why didn't you," screamed Peggy, furious with Larkin for what he had done, furious with him for not defending himself, furious with herself for being out of control. "What kind of monster are you to let a friend die like that?"

Larkin looked up, and Peggy saw the tears rolling down his face. "Trying to do what's best. Trying to save your universe."

"Hah," cried Peggy, still enraged, but feeling sorry for Larkin after seeing his tears. "You can't even save one Jenfu worrier. How are you going to save a whole universe?" she asked bitterly.

"To save your universe, I had to let Arnue die."

"That's stupid. Why did Arnue have to die?"

"If I had used my power to save him, Gurnacht would have known we are here just as surely as if I had sent a note to his castle saying I had arrived and would like to meet him. What would that have gotten us? The four of us would now be dead, unless Gurnacht decided to torture us. The Jenfu would have suffered, too. Gurnacht would have been reminded of them, would have been furious that they were working against him. He would have slaughtered the Jenfu, including Arnue.

"What would we have gained for Arnue and his people? Nothing but death. That's why I didn't act. It's the hardest thing I've ever done in my life, Peggy. I almost used my powers to save Arnue, but saving him would have led to much greater evil."

"He's right." Donnie spoke quietly, still staring at the floor. "We're here to save our world and our universe, and perhaps rid creation of an evil monster. Some loss may be involved. Larkin told us that. We have to accept that and do all we can to achieve our ultimate goal. Strange. Kind of like what Coach Cochran always says about a football game. To win, you may have to suffer. Only here, with what we're doing, the suffering is a lot greater than a few bumps and bruises in a football game."

"You believe that, Donnie?" asked Peggy.

"Yes. I think you're being unfair to Larkin."

"Unfair?" snapped Peggy, her eyes flashing.

"Yes, unfair. He did something that's tearing him apart, and he needs our support."

"Thanks, Donnie," said Larkin.

As Peggy listened, her anger, hurt, and frustration began to evaporate. She couldn't deny the truth of what Donnie and Larkin said, much as she wanted to. As her anger faded, Peggy saw the terrible pain and hurt in Larkin's face. She realized how unfair she had been, and how she had hurt Larkin. In an eye blink, she was beside him, her arm about him, holding him close. "I'm sorry," Peggy whispered. "I didn't understand. I was so mad about Arnue that I didn't see anything else."

"I'm glad you understand. I can't tell you how much it hurt not to help Arnue."

Regina began to hum, and the music helped seal the new friendship between Larkin and Peggy, a friendship born of suffering.

"I still don't know if what I did was right. I wonder if my father would approve?" Larkin dropped his head in dejection.

"I don't know," said Peggy. "I would have saved Arnue first and worried about the consequences later. But if you're right, that would have destroyed any chance of saving Earth."

"It's kind of like being a quarterback," said Donnie. "I call a play, thinking it's going to lead to a score, but I don't know for sure. I can only do my best each play and accept the results. I think you have to do the same, Larkin."

"You think what I did was right?"

"Yes."

"I do, too," said Shu. No one had seen him standing at the door.

"You do?" asked Larkin in surprise.

"Arnue was my trusted friend of many years. He knew what you are trying to do, and he greatly respected your courage. He would have understood why you didn't use your power to save him—and would have approved. He was a great warrior—fearless in battle with the evil creations of Gurnacht. I assure you, he would have willingly given his life if he thought it would help defeat Gurnacht because only then will the Jenfu be free. And Arnue wanted freedom for his people."

"Thank you, Shu. That helps," said Larkin.

"Now my friends, we gather to honor the passing of Arnue. We'll feast to celebrate his life. My people would like you to attend. Arnue's wife has asked if Regina would sing an appropriate song at the end." He looked questioningly at Regina.

"I'll sing for Arnue," she answered, then whispered to Peggy, "What shall I sing?"

"Think of the most beautiful song you know."

Regina nodded.

A solemn quiet permeated the great hall as Shu led the four travelers to the spot where he would address the assembly. Even the smallest children sat quietly next to their parents.

"My friends," began Shu, "we gather to celebrate the life of our good friend and comrade, Arnue. We remember his goodness and his willingness to help others who were less fortunate. We remember his honesty. Arnue never broke his word, and that's a great thing to say of a person, and worthy of much praise. We remember his courage, courage he tested again and again against the evil of Gurnacht. In the end, he gave his life to help defeat that evil by saving the singer of beautiful melodies from the beaks of the vultures. His life was a mighty victory and worthy of many songs.

"As with every celebration of passing, we shall now have the passing song. Arnue's wife has asked Regina, who Arnue saved, to sing the passing song."

Peggy saw many tears on the faces of the Jenfu as Regina sang Shubert's *Ave Maria*. All the Jenfu had loved and respected Arnue.

After a moment of silence at the end of the song, Shu rose to speak again. "We now celebrate Arnue's life with a feast in his honor. Let us feast with joy and laughter. Let us remember Arnue's great deeds and those good deeds that marked his life."

Later in the evening, as the feast came to a close, Shu took the travelers back to their sleeping nook. "We must talk about tomorrow," Shu said. "I think you should leave early, well before dawn, before the vultures are up and flying."

"Who will guide us?" asked Peggy, thinking of Arnue.

"Yolan will be your guide. He is a superb woodsman, full of courage and knowledge. Arnue trained him, and he won't lead you astray. But there is something I wish to ask. Have you considered why the vultures attacked Regina? Why her instead of Larkin or Peggy or Donnie?"

"I thought it was because she had fallen behind the rest of us," said Peggy.

"I've thought about that," said Larkin. "When I chose Regina to come with us, my intuition said that she was important to the success of our mission. But I didn't know exactly how. I still don't, but the vultures have proven to me that Regina is more important than the rest of us if we're going to defeat Gurnacht."

Regina dropped her head and blushed.

"If that's true," said Peggy, "then we have to make sure nothing happens to Regina. I promised to stick close to her, but I forgot. I won't forget again."

"She still hasn't faced her vision," murmured Donnie.

"That worries me," said Larkin. "We must be prepared to help when Regina enters her vision. We must protect Regina at all times. Do you agree, Shu?"

"Yes. I think Regina is crucial to your success. The vultures knew that she was a far greater threat than you other three." Then Shu took his leave for the night, saying that they should get some sleep and that he would call them in a few hours.

"I'm sorry I got you all into this," said Larkin after Shu left. "I knew we faced danger, but I didn't know how great that danger

would be. I was wrong to think I would be the one most at risk."

"That's okay, Larkin," said Peggy. "You couldn't know for sure what we'd find here."

"If you want," said Larkin quietly, as he stared at the far wall, "I'll take you home. I have no right to ask you to face the danger that awaits us when we leave this cave."

"What will you do after you take us back?" asked Donnie.

"I'll come back here. I know I don't have much of a chance, but I have to try to stop Gurnacht."

"Well?" said Donnie, looking at Peggy and Regina.

"I want to go home in the worst way," said Peggy slowly. "I want to be back in my grandmother's house. I want a nice, hot bath and a clean, soft bed to sleep in; but if I leave now, I would regret it the rest of my life knowing that I might have saved Earth. I'll go on with Larkin."

"Regina?"

"Me, too."

"Then it's settled," announced Donnie. "The musketeers will stay together."

Larkin looked at them with surprise on his face. "I thought," he stammered, "that you'd all want to go home."

"We're hard people to figure out," said Peggy with a smile on her face. "We all want to return, but we're going to stay anyway. Now, let's get some sleep. I'm beat, and I'm sure tomorrow will be nasty."

CHAPTER 9

Peggy could see nothing in darkness thick and black as old motor oil. From the moment she left the cave, she placed all her trust in the little people who guided them.

Yolan said they would cross two mountains before they reached the Stairway to Darkness. Peggy wasn't sure how she could climb another mountain. *Maybe I should have returned to Earth. Gurnacht will probably kill us anyway. Larkin said his power was useless against Gurnacht. Coming here sounded so grand back in Larkin's house. Now it sounds stupid.*

Slowly, the forest turned into a world of dark, blue-gray shadows. Peggy saw Jenfu slipping through the forest, quiet as field mice. She hadn't realized so many Jenfu protected them. *Why would Shu send so many warriors? Not a good sign. He must be more worried than he let on. I wonder how many wolves live in this forest?*

Peggy pulled herself up a steep incline, using bushes that looked like mountain laurel as hand holds. Her feet kept slipping out from under her. Even the Jenfu struggled. As she reached the top of the incline, she realized they had reached the summit of a mountain. She spotted a flat rock and collapsed on it. Her friends sat close by, all trying to catch their breath.

"You've done well," said Yolan. "This mountain is difficult to climb, even for us."

"Will the next be easier?" asked Peggy.

"The second mountain isn't so high, but it has special dangers."

Peggy groaned. She was tired of danger. Tired of walking. Tired.

"How so?" Donnie asked Yolan.

"The second mountain is more open and exposed. Vultures have a better view of anything moving on the mountain. Wolves also roam there more freely than they do around our home cave. But let's put aside fear for a few moments. You're going to see one of the great beauties of this world, the sunrise over Mount Arankesh. The Stairway to Darkness begins at the foot of Mount Arankesh, and Gurnacht's castle is at the top. But from here, we'll see a glorious sunrise."

Peggy looked to the east, the direction they had been traveling,

and she saw the twin peaks of a mountain rising into the sky. The peaks looked like giant church steeples thrusting up to the heavens. Peggy had only seen pictures of the Colorado Rockies, but she was certain that Mount Arankesh rose much higher than the highest mountains in the Rockies. The tops of the twin peaks were lost in heavy, gray clouds that crowned the mountain.

As Peggy watched, the rim of the sun rose into the sky at the lowest point between the two peaks. Shafts of red light shot towards them. The heavy clouds hanging over the mountain turned a deep crimson, then lightened into pastel pinks as the sun rose higher. Peggy had never seen a more glorious symphony of colors.

"I love this spot," murmured Yolan. "I wish I could come here more often—and come in safety."

"I can understand why," said Peggy, still awed by the rising sun.

"In front of Mount Arankesh, you can see the second mountain we'll climb," said Yolan, pointing to a small mountain between them and Mount Arankesh.

"That river in the valley," said Donnie, pointing to a winding strand of silver foil in the middle of the valley. "Will crossing it be difficult?"

"No. We have a rope bridge."

Peggy felt her heart skip a beat. *I don't like the sound of that. I can't stand heights. Going up a ladder makes me dizzy. I can't imagine crossing a river on a rope bridge.*

"We'll rest here briefly," announced Yolan.

The Jenfu produced bread and fruit, and the travelers enjoyed every bite of the simple fare. The food made Peggy feel less pessimistic. She leaned back against a tree and closed her eyes. A loud voice startled Peggy awake.

"Yolan. Look," cried one of the Jenfu.

All eyes turned east, toward Mount Arankesh. Many dark spots hovered in the distant sky.

"Vultures?" asked Larkin.

"Yes," replied Yolan. "We must get under cover."

"You okay?" asked Donnie, as Peggy got slowly to her feet.

"I think I could have slept under that tree for the whole day. I feel like a truck ran over me."

"I know. It's like the first week of football practice. No matter how I try to prepare, I'm always stiff and sore. That's what you're feeling. You'll feel a little better each day. Honest." Donnie smiled.

I'm glad he wasn't sarcastic like he always was at school. He's changed. Ever since his vision, he's been nicer. I'm actually starting to like him—and to trust him.

Going down the eastern slope of the mountain was not much easier than the climb up. Leaves were slick from the rain the previous night. Peggy could never seem to get a firm footing, and she stumbled frequently. Being in a hurry didn't help. The faster she tried to move, the more she slipped and stumbled. Only the help of the Jenfu kept her from having a serious accident. The Jenfu had no problems as they darted down the mountain. Peggy marveled at their skill and their swiftness afoot.

The canopy of trees in the river valley was not thick, and numerous spots opened to the sky. The Jenfu showed the travelers how to slip from tree to tree, staying in the shadows and being inconspicuous.

"Stupid birds. They really mess things up," groaned Peggy.

After two hours, Yolan called a halt. "We'll see if the vultures are still in the air."

One of the Jenfu scrambled to the top of a high tree to check the skies. "No vultures anywhere," he said, after descending.

"Good," replied Yolan. "Perhaps they're concentrating on the area around the cave. They probably don't suspect that we left so early. I think we'll trust to luck and go back to a normal march. We need to make up time." He led the band off at a quick pace.

"Larkin," said Peggy, as they strode along, "I'm worried about crossing the river."

"Don't worry. Yolan said there was a bridge. It shouldn't be difficult to cross."

"For you, maybe not. But I'm afraid of heights."

"Oh," was all Larkin said, but his eyes showed concern.

"How am I going to get across if the bridge is high above the river? I'll freeze. I know it."

"Don't get too worked up. The bridge will be a piece of cake."

"I hope so," said Peggy, not in the least convinced by Larkin's assurances. She continued to worry as they sped along.

They reached the river at mid-day, and the bridge confirmed Peggy's worst fears. The river roared in white-water fury through a deep gorge. The only way to cross to the other side was two strands of rope—one for feet and one for hands—strung over the gorge. The ropes swung two hundred feet above the water. Mist from the

cataracts below made the ropes damp and slippery as wet eels.

"I don't think I can do this," said Peggy.

A few of the Jenfu walked skillfully across. Yolan frowned.

"We have to cross," said Larkin, holding Peggy's hand. "You can do it."

Peggy stared down into the water, and she felt vertigo well up inside and threaten to pitch her into the gorge. She jerked back from the edge. "I don't think so," she murmured. "I'd fall for sure."

"Any ideas?" Larkin asked the others.

"What if Peggy got on my back and closed her eyes? I think I could carry her across," said Donnie.

"Could you do that?" asked Yolan, marveling at such strength.

"I think so. Let me try the rope out first."

"Be cautious," said Yolan. "The rope is slick."

Donnie worked his way out on the rope, testing the amount of play as well as the footing. When he came back, his face was grim.

"Can you do it?" asked Larkin.

"I think so. Are you willing to try, Peggy?"

"If you are."

"Then let's go. I don't want to be in the middle of that rope and have a vulture spot us."

Peggy reached up and put her arms around Donnie's neck as he helped her get situated on his back.

"Peggy, I never thought much of skinny girls before, but this is one time I'm glad you don't weigh much."

"Me, too. Thanks for doing this."

"Thank me after we get over. Keep your eyes closed and keep a tight grip. Don't worry about choking me unless I say something."

"Or you stop breathing."

Donnie grinned and chuckled. "Right."

A seething river of fear coursed through Peggy's veins, no less violent than the waters rushing through the gorge. Nothing petrified her more than high places. Donnie inched his way across the rope, and Peggy could feel him strain to keep his balance. Twice she heard him gasp as he briefly lost his balance, and her heart thundered in her ears. Each time, Donnie fought successfully to regain his footing.

Without warning, Peggy felt herself falling, though she still gripped Donnie's neck. The sensation was not what she expected. One moment they were on the rope, and the next, her stomach was above her as she plunged toward the river. Then Donnie grabbed the

footrope with his hands. The rope bounced wildly up and down, threatening to shake them off, and Peggy felt her grip weaken.

"Hold on," gasped Donnie.

Peggy felt him start to swing his body like a pendulum. When he had momentum, he began to move hand over hand toward the bank. Donnie's breath came in great explosions. Peggy took a quick peek. Ten feet away, Jenfu waited with hands extended. As soon as Donnie was close enough, hands grabbed Peggy and lifted her to safety. The same hands helped Donnie up.

"Thanks, Donnie," Peggy panted in a small voice, as she stared back over the gorge. She couldn't stop shaking.

A small smile played about Donnie's mouth. "I wasn't sure we were going to make it." He shrugged his shoulders almost apologetically.

The others crossed over without mishap. "That was incredible," said Regina, looking at Donnie with wide, adoring eyes. "You were awesome."

"Lucky, Regina." Donnie blushed and looked away.

Peggy couldn't help liking Donnie for that. *My opinion of Donnie has really changed. Back at school, he would have agreed that he was the greatest. But he's changed. He's actually likable.*

"Are you okay?" Larkin asked Peggy, as soon as he scooted across the rope.

"I'm fine," declared Peggy, trying to regain her composure, though she was still shaking.

"I was petrified," said Larkin, putting his arms around Peggy and gently holding her close.

Peggy thought she might be willing to go through the whole thing again if it meant being held by Larkin. His arms felt so good, and the warmth of his body felt reassuring. She also sensed the power she had once glimpsed back in his study, and that calmed her.

"I don't want anything to happen to you," Larkin whispered quietly. "You mean too much to me. Understand?"

Peggy stopped shivering, stopped feeling afraid as she nodded to her best friend.

"I know you'd like to rest," said Yolan, "but the day passes. We must get to the Stairway to Darkness before nightfall."

The afternoon passed without incident as the band moved across the valley and up West Mountain, the mountain that stood before Mount Arankesh. As the weary travelers stood on the summit of

West Mountain, they got an impressive view of Mount Arankesh in the full light of the westering sun. The mountain towered high over them, with the twin peaks lost in dark storm clouds that swirled about the crown.

"There," said Yolan, pointing to the base of the mountain. "The Stairway to Darkness."

Peggy saw a rocky cliff rising thousands of feet from the valley floor up to a high mountain plain. "We have to climb that?" she asked.

"The climb is difficult but not impossible if..." Yolan's voice trailed off.

"If what?" asked Donnie, wanting all the information he could get before tackling the mountain.

"If there are no storms or vultures," Yolan said grimly.

"Vultures?" questioned Regina, fear in her voice.

"Sometimes vultures will attack those who climb the Stairway to Darkness."

"And the storms?" asked Donnie.

"Sometimes the clouds you see surrounding the top of the mountain will sink down, and the stairway is lashed by fearsome storms. I saw such a storm once. I've never seen anything like it in my life. Lightning flowed from the clouds like rivers of light."

"I hope we don't have to face that," muttered Donnie.

The travelers reached the foot of Mount Arankesh as the sun dipped behind West Mountain, and the shadows under the trees deepened into dark blues and purples. Peggy felt less safe than she had during the day, though the Jenfu warriors gave her some comfort.

They pitched camp on the edge of the forest at the foot of the Stairway to Darkness. The cliff, which had looked imposing enough when Peggy saw it from the top of West Mountain, now looked forbidding.

"It's a mighty rock you'll climb tomorrow," murmured Yolan, who stood at Peggy's side.

"I thought there would be some sort of path to follow—or a bunch of steps to climb. I didn't know we'd have to climb a sheer cliff like this. How we can do it? We aren't rock climbers."

"Right now, it looks hopeless," said Yolan. "But there are ledges and indentations along the face of the cliff. You don't need to be expert rock climbers to get to the top. You won't even need ropes."

Peggy turned to Larkin, who had just walked up with Donnie and Regina. "I can't climb that. I can't even climb a ladder without getting dizzy."

Larkin looked worn and gray in the falling light. He took Peggy's hand in his. "I didn't know heights scared you. I'll take you home, and if Donnie and Regina want to go with you, that's okay, too."

Peggy was aware of the Jenfu gathered about them listening intently to the conversation.

"What will you do?" Peggy asked Larkin.

"I'll come back here and hope that Gurnacht is too busy with other things to notice an apprentice weaver messing about. I'll climb the Stairway to Darkness in the morning."

"But you can't face Gurnacht alone," said Donnie. "You said so yourself."

"I said I didn't think I'd have much of a chance," said Larkin, speaking in a low voice. "But saving Earth is worth a try."

Donnie nodded. "Two of us have a better chance than one. Take the girls back, and I'll wait for you here."

Peggy couldn't believe her ears. "You're staying?"

"I have to," replied Donnie. "I know it doesn't sound like me—the me you knew at Newville High—but for the first time in my life, I see something more important than what I want. Surprising, huh?" Donnie laughed self-consciously and stared at the ground.

"I'll say."

"What about you, Regina?" asked Larkin.

"Peggy's my friend, and I don't like to leave her. But you're my friend, Larkin. So is Donnie, I think." Donnie nodded and smiled at Regina, who blushed. "You said I was important if we were going to succeed. I've never been important to anyone before. I'll try to climb the Stairway to Darkness. You'll need to help me, though. I'm not a good climber."

After what we've been through, they're my three best friends. How can I let them down? But the cliff. How can I face that? I get sick just thinking about it. My legs will turn to spaghetti the minute I get ten feet up. What good will I be then? But I can't leave my friends.

"If you stay close to me, Donnie," Peggy said slowly, "and help me, I'll stay."

"I'll be your shadow, Peggy. You can do it."

The Jenfu smiled. Larkin frowned.

"This is good," said Yolan. "Now we must prepare camp.

Tonight we keep watch. There is much evil in these woods."

The night dragged slowly by. Peggy didn't sleep well. She kept thinking about the Stairway to Darkness. She kept wondering if she could climb it, if she could make her legs work once she started up the cliff. When she dozed, she dreamed she was climbing a steep cliff. She would lose her footing and pitch down toward jagged rocks below. She always woke with a violent jerk before she hit the rocks. By morning, Peggy felt as though she had already climbed the Stairway to Darkness. Daylight barely creased the darkness of the forest below Mount Arankesh when Peggy heard the high-pitched howling of wolves.

"Quickly," yelled Yolan. "To the Stairway. The wolves will be here in minutes."

The travelers grabbed their packs and rushed after Yolan, who led them to the base of the cliff, which was not as sheer as Peggy thought.

"Start here," said Yolan rapidly. "Work up the cliff toward your right. Always work to your right. You may see opportunities to go left, but avoid them. Our legends say they lead to disaster."

"What do legends say about the top?" asked Larkin hurriedly.

"Little. Only that Gurnacht's castle is on the right-hand peak. I wish I could tell you more."

A pack of howling wolves broke from the forest and rushed toward the band.

"Go," yelled Yolan. "We'll keep them back until you're out of reach."

Jenfu archers were expertly dropping wolves that came within range of their arrows. Peggy was glad that Shu had sent so many warriors. Had there been fewer warriors, the wolves might have overrun them.

"You lead, Larkin," cried Donnie. "Then Regina. I'll follow with Peggy."

The four companions clambered up the cliff. At first, wide cuts in the rock made climbing easy. Within minutes, they came to a spot where they had to climb straight up, using little outcroppings of rock for their hands and feet. They climbed up fifteen feet to a ledge where they stopped to catch their breath.

"At least we know the wolves can't get us now," gasped Larkin, looking back to the foot of the mountain where the Jenfu, bunched together, were moving back into the forest. Wolves howled at the

little people, but no longer ventured within arrow range. Numerous gray bodies lay scattered about the clearing where the travelers had been moments before.

"Everybody okay?" asked Donnie.

"I'm all right," said Regina.

"Not so good," murmured Peggy, who glanced down from their perch. Sickening vertigo swept though her.

"The height?" asked Larkin.

"Yes."

"Don't look down," ordered Donnie. "When we stop to rest, keep your eyes closed. When we climb, look up. I'm right here. I won't let you fall."

"Just knowing where I am makes me feel all queasy inside." Peggy closed her eyes. She felt sick in her stomach, and her legs turned to water.

"This is going to be the toughest part of the journey, I think," said Donnie seriously. "We can't make any mistakes."

"We also have to get to the top before night," said Larkin. "We can't survive a night on the cliff if the weather turns bad."

"At least the weather is good," said Regina.

"Let's hope it stays that way," murmured Larkin as he surveyed the sky.

"We better get moving," said Donnie. "Let me know if anyone needs to rest; otherwise, let's keep climbing. We'll take it slow so we don't risk any accidents, but we have to keep moving."

Peggy climbed in a swirling nightmare of pain and fear. Only Donnie's steady hand helping her and his reassuring voice kept her from disintegrating into a blubbering fountain of tears. She made every effort to keep her eyes on the rocks before her, but she couldn't shake the knowledge that she was high on a cliff, higher than she had ever been in her life, and only a step away from a fall that would kill her. Sometimes that thought would envelop her mind so completely that she would freeze to the side of the cliff and not be able to move until Donnie had gently encouraged her. Once, he had to pry one of her hands loose from the hold she had on a rock.

They would climb a short distance, fifty to a hundred feet, stop, as Donnie and Larkin mapped out the next segment of the climb, then continue. By late morning, the travelers had completed a third of their journey.

"We need to rest," gasped Larkin at the end of one grueling

climb across a rock with few holds for their hands and feet. "I need something to eat and drink."

"Me too," agreed Regina, who had been humming almost constantly as she climbed. Peggy wished she could hum, but fear drove everything from her mind, including all the music she knew.

"Okay," said Donnie. "I need a rest, too. How are you doing, Peggy?"

"Managing," gasped Peggy through clenched teeth. They stopped on a wide ledge, and Peggy sat with her back pressed against the cliff wall. She did not look out. She fixed her eyes on the pack resting between her legs as she pulled out dried fruit. She kept her eyes on the ground as she ate—or she closed them. She didn't know which was worse, the fear that pounded through her or the exhaustion that invaded her body.

"We can't rest long," said Donnie. "It's going to be a race to make it to the top before the sun sets."

Peggy heard herself say, "Okay, then let's get going." She could hardly believe it was her voice. She almost smiled.

The wide ledge they had rested on wound up the face of the cliff, and the travelers moved quickly. "I wish this would go the whole way to the top," said Donnie. "This is like a freeway compared to what we've been on recently."

Suddenly, the air shimmered and brightened. Regina walked past a surprised Larkin, stepped off the ledge, and entered her vision.

CHAPTER 10

Regina stood in the middle of twelve Newville High cheerleaders milling about the gym floor.

"Who will be captain?" squealed Carla, excited about the selection of officers for the cheerleading squad.

"Is there any doubt?" replied Alison, a smile on her face.

"Regina will be a super captain."

"She's the best cheerleader the school has ever had. I heard Mr. Strite say that, and he's been here forever."

"Girls! May I have your attention," cried Miss Webster, the cheerleader advisor.

"Who is it, Miss Webster?" yelled Kathy.

"Yeah, who?" squealed Alison.

"Our lieutenant will be Carla Hernandez, and our captain will be...." Miss Webster paused dramatically. "Regina Conley."

Congratulations rang out. Regina smiled and hugged Carla. When the hubbub died down, Regina spoke. "I want this to be the best squad in the history of Newville High. I think we have the talent to win the state cheerleading title in the spring, and that's what we're going to work for. Are you with me?"

The girls screamed *yes* and bounced up and down, letting Regina know they would do anything for her.

"She wants to be popular," said Donnie in amazement, as he watched Regina's vision. "I never thought Regina wanted the same things I do, I mean, well, because...you know."

"We all want to be popular," said Peggy. *Regina wanted to be like everyone else. She wanted to be accepted, but she was an outsider—an outcast, really. No one knew how much it hurt her to be laughed at, or never asked to join in. But even I didn't realize how much she wanted to be popular. I doubt that I could have handled all the rejection Regina faced over the years as well as she did.*

"This may be the toughest vision of all to break," said Larkin.

"You think so?" asked Peggy. "Regina has always been pretty practical about stuff, especially about who she is."

"But popularity is what she's always dreamed about. Now she has lots of it. I don't think she'll give it up very easily."

"Look," said Donnie. "The vision's changing."

Regina stood near the main entrance of Newville High. She talked to a tall, handsome boy.

"That's Ted," exclaimed Donnie, "captain of the basketball team."

"Will you go to the homecoming dance with me?" asked Ted.

"Oh, I'd love to, Ted, but I was asked to the dance weeks ago. I'm really sorry."

"Who asked you?"

"Donnie Himler."

"Oh, wow. I can't believe you'd go with him. You know what kind of reputation he has."

"I know. But when he asked, I didn't have a date, and I didn't feel right about lying to him."

"Couldn't you break the date?" pleaded Ted, obviously not used to having girls turn him down. "No one would blame you. Most people will think you're crazy to go with him."

"I don't like to break dates. It's not right."

"We'd make a great couple. We might be king and queen of homecoming if we're together."

"Do you think so?" asked Regina, a little breathlessly.

"It's almost a sure thing. If you're with Donnie, no chance of you being chosen."

"I'd like to be queen. Let me think about it, okay? I'll tell you tomorrow."

"Great. See you tomorrow." Ted walked jauntily off.

"So this is what Regina wants most?" asked Donnie, a frown on his face.

"Can you blame her? She's been an outcast all her life."

"No. I can't blame her." The frown remained on Donnie's face.

"What's the matter?" asked Peggy, who had never seen Donnie look so serious.

"While I was watching Regina's vision, I realized what a total jerk I've been. People pretended to be my friends because I'm a good football player, but nobody really likes me."

"There wasn't much to like."

"You're right," said Donnie, as he looked into Peggy's eyes. "Maybe I can change that."

"I think you already have," said Larkin.

"You think so?"

"You have, Donnie," agreed Peggy. "But let's talk about that later. What are we going to do about Regina?"

"Look. Another change," said Larkin.

The principal of Newville High stood on the football field before a microphone. A golden harvest moon hung in the sky over the press box. Seven smiling girls in formal dresses stood in a half circle behind the principal. "It gives me great pleasure to announce this year's homecoming queen, who is also, I might add, our student council president–Regina Conley."

Cheers rolled down from the stands as a beaming Regina and her escort stepped forward. The principal placed the crown on Regina's head. Regina waved to the crowd, then, along with the six other girls, mounted the homecoming float as the vision changed again.

"Hi, Regina," said Ted. The two stood alone in a school hall.

"Hi, Ted. How are you?"

"Good. The team is shaping up, and I think we'll have a good season."

"I hope so. It's more fun cheering for a winning team."

"I'll bet it is. Listen, I wondered if you'd like to go to a movie Saturday night?"

"I'd love to Ted, but I have a swim meet that night. College coaches will be there to watch me."

"Oh, right. You're pretty good, aren't you?"

"I've already had a couple of scholarship offers."

"Gee, that's great. I didn't know you were that good. Well, since you're busy Saturday, how about Friday night? I won't keep you out late."

"I'm sorry, Ted, but I already have a date."

"It's kind of hard to catch you with any free time, isn't it?" Ted looked unhappy.

Regina shrugged. "Try again?"

"Sure. Well, got to get to practice. See you."

"This is going to be so tough," said Peggy, as the vision shifted again. "She won't want to leave the life she's leading in this vision. It's everything she's ever dreamed about."

"We need to get her out of that vision," said Larkin. "Without her, I don't think we can defeat my uncle."

"We also need to get to the top of this cliff before dark," declared Donnie, "and we don't have much time. We still have a long climb."

The vision shimmered in front of them, in the open air just off

the ledge where Donnie, Larkin, and Peggy watched in fascination.

"Peggy, you're Regina's best friend. You'd have the best chance of getting her to leave. See what you can do," urged Larkin.

"I'd have to step off the cliff," stammered Peggy. "No way I can do that."

"But you'll step right into the vision. You won't fall," insisted Larkin. "You know how these visions work."

"I know, but I can't step off this ledge. I just can't—not for anything in the world." Peggy moved closer to the face of the cliff, as far away from the ledge as possible.

"If I go with you?" asked Donnie.

"You can step off?"

"If I have to. I know we won't fall."

Peggy looked into Donnie's eyes for a long moment. *He's scared, too. But he's going to do it anyway. He believes in Larkin and what Larkin is trying to do. Amazing. He'll step off into thin air because he believes it's important.*

"Okay," Peggy said, taking a deep breath and grabbing Donnie's hand, "let's go."

"Close your eyes," said Donnie as he led Peggy into the vision.

Regina stood in front of the assembled school in the auditorium. "As current president of the National Honor Society, I am pleased to announce the new members—Tim Bradford, Marcellus Winston, Jill James, and Sandy Ryan. I shall now turn the podium over to the president for next year, Carol Yates." When Carol reached the podium, Regina walked into the wings.

"Regina," called Peggy. "Come over here." She and Donnie stood in a dark corner.

"Hi, Donnie," said Regina. "Are we still on for Saturday?"

"Sure, Regina."

"Regina, don't you remember?" asked Peggy.

"Remember what?"

"Our mission with Larkin."

"Larkin? Mission? What are you talking about? Donnie, what's this all about?"

"You don't remember anything about going to Larkin's dimension? About Gurnacht? About the threat to Earth?"

"Donnie, are you playing games with me? What nonsense. Listen, I have to get to the gym. I'm meeting with the swimming coach from Notre Dame. I think," she whispered conspiratorially, "they're going

to offer a full scholarship. I'm like so excited, I can hardly stand it."

"Do something, Larkin," Peggy whispered into the air.

"Who's Larkin?" asked Regina.

"A friend," replied Donnie.

"Hi, Regina," said Larkin, who appeared behind her.

"Do I know you?" asked a perplexed Regina.

"You don't remember me?"

"Your face looks kind of familiar, but I can't think where I've seen you before."

"Use your power, Larkin. She has to wake up," cried Peggy.

"I can't. If I did, Gurnacht would know. None of us would ever leave this vision."

"What are you talking about?" exclaimed Regina. "I'm beginning to think you're all crazy."

"Hey, Regina, can I walk you to the gym?" said Donnie, a big smile on his face.

"Sure. I'd like that."

Donnie took Regina's hand and pulled her out of the vision. Larkin and Peggy followed. Once again they stood on a ledge a thousand feet above the forest below.

Regina stood blinking her eyes like an owl. "It was so real. I knew Larkin meant something to me, but I didn't want to think about it. I didn't want to leave."

"I know," said Peggy sadly, as she thought about the room with the warm fire and her mother and father drinking hot chocolate. She hugged Regina and felt her trembling.

"I want to go back," mumbled Regina, almost to herself, as she turned toward the spot of the vision.

"Too late," said Peggy, gently holding on to her. "I'm sorry, Regina. I really am."

"But I want to go back. You tricked me, Donnie."

"I know," Donnie said, his shoulders slumped, his eyes sad. "But without you, we can't defeat Gurnacht."

"I don't care," said Regina, and a tear dribbled down her right cheek.

"We need you, Regina," said Peggy softly. "The vision was all fake. No one in the vision needed you–really needed you. We do. You're important in a real world. You're the most important person in our whole universe. Without you, everything will be destroyed."

Regina perked up as Peggy spoke. "You really think so?"

"I know so," exclaimed Larkin. "You give us a chance to defeat Gurnacht."

"But how? I don't understand. I'm just a retard."

"Regina," yelled Peggy, and frowned at her friend.

"Sorry. You know what I mean."

"I don't know how, Regina, at least not yet. I only know that, somehow, you're the one who gives us a chance at victory."

"We've got to get moving," said Donnie, "or we won't make the top before dark."

"Then let's get on with it," said Peggy. "I hate being on this cliff."

The wide ledge narrowed, and the travelers moved cautiously. The bright sun warmed them and warmed the rocks, which helped when hand holds were small. When they stopped for a break in mid-afternoon, Donnie was pleased. "I didn't think we'd be able to come so far so fast. We've covered at least three quarters of the distance. We should make the top before dark."

The cliff, which until this point had been relatively sheer, now gave way to a large fall of rocks that rose five hundred yards up to a final cliff, which would bring the travelers to the high mountain plain they had seen the day before as they stood on West Mountain.

"Looks like an avalanche created this," said Donnie, as he stared at the rocks.

"This should be easy climbing, shouldn't it?" inquired Peggy. Anything that got her off sheer cliffs made her feel better.

"Yes," said Donnie. "But we need to be careful. We don't want any accidents this close to the top. Watch your footing."

The climbing wasn't as easy as Peggy had hoped, but she didn't worry nearly as much about falling. They often slipped and slid on the huge boulders they had to climb over. When possible, Donnie led them through cracks and crevices that formed small tunnels around or under the towering hunks of granite.

"Last part of the Stairway to Darkness," announced Donnie, as they stood below the final section of the cliff. It rose less than a hundred yards to the plain above.

"It doesn't seem to be quite so sheer," observed Larkin. "Looks like plenty of ledges and handholds."

"Let's get at it," cried Peggy. "The sooner we're done with this, the better."

Donnie led the way, and the climbing was easier than before, though Peggy still refused to look down. No one noticed the dark,

boiling clouds sinking toward them from the summit of Mount Arankesh. The darkness took the climbers by surprise, a darkness that made it difficult to see the next hand hold and impossible to see more than a few feet in any direction. A fierce wind sprang up and swept across the mountain.

"There," yelled Donnie, above the howling wind that swept down on them, trying to rip them off the cliff and toss them into the blackness below. He pointed to a crevice only a few feet from him. "Get into the crevice. Quickly."

The three climbers scrambled by Donnie and pushed into the small opening. Rain lashed the cliff as jagged bolts of lightning splintered the sky. "Will we have to stay here all night?" asked Regina. "I'm cold and wet, and I don't feel so good."

"I hope not," said Donnie. "Maybe the storm will blow over quickly, and we can get off the cliff before dark. Is this something from your uncle, Larkin?"

"I don't think so. Just a nasty storm."

The storm howled about the mountain for twenty minutes, and then, as if a magician had waved his magic staff, the clouds lifted. Shafts of golden light from the departing sun in the west stabbed the darkness.

"Come on," yelled Donnie, leading the way up the cliff. The wet rocks made climbing treacherous, and the cold wind still buffeted them. Their hands went numb, making it more difficult to grip the rocks. As the light faded in the west, the climbers struggled to the top of the Stairway to Darkness.

"I can't believe we made it," gasped Peggy. "I hope I never have to climb a mountain again."

"Everything after this will be a piece of cake," said Donnie. "You did a great job, Peggy."

"Thanks." Peggy never thought a compliment from Donnie would please her so much.

The travelers stood on a high plain that stretched away into the dimming light. The plain angled up toward the two great peaks, now lost in darkness. All before them was brown, rocky, and barren. An icy wind flowed down the mountain, and the four travelers shivered, in spite of their warm clothing.

"According to the Jenfu, Gurnacht's castle is on that peak," said Donnie, pointing toward the right peak.

Larkin stood quietly, looking up into the darkness. "Yes," he said

after a moment. "I can feel him there, plotting, watching his evil creations."

"Then we go that way. Everyone okay?"

"Donnie, I'm so tired I think I could go to sleep on my feet," yawned Peggy.

"Me too," agreed Regina. "I need to rest."

Donnie looked across the plain. "We have to keep going until we find shelter." As he spoke, the sky filled with snowflakes. In moments, the ground lay under a white blanket.

"What now?" asked Peggy.

"Big problems," muttered Donnie. "This snow is going to make walking next to impossible if it gets deep. We have to find shelter. We'll never survive the night in the open."

"Let's head toward the castle," said Larkin.

"That's as good a direction as any," agreed Donnie.

"I can't go very far," said Regina.

"I know. We'll find cover soon." Donnie was less hopeful than his words. He had a vision of the four of them dying of cold and exposure on this high plain, so close to their destination, yet so far away.

CHAPTER 11

The snowfall increased as the weary travelers trudged across the barren plain–first an inch, then three inches. Before thirty minutes passed, they were plowing through six inches of snow. Still the snow fell, and the wind blew. Their tracks disappeared almost as soon as they picked up their feet.

"Stay close," yelled Donnie, above the howl of the wind. "Don't get separated. We'd never find each other in this blizzard."

"We need shelter," said Peggy, whose legs shook with fatigue. *I can't go much farther. My legs won't carry me, no matter what I tell them. We're so close to the castle, too. I hate being a drag on the others, but I have to rest.*

But the wide plain offered no shelter and no wood for a fire, not that they could have started a fire in the blizzard that was fast burying them. The wind sliced through them like a sharp knife cutting through a warm muffin.

The four friends slogged along for another ten minutes before Regina stopped. "I can't go any farther," she said. "I have to sleep."

"No," yelled Donnie. He grabbed Regina and shook her. "We can't stop. We'll freeze."

"I don't care," replied Regina, in a daze. "I have to sleep."

"Peggy, keep Regina awake."

"Okay," said Peggy, who yawned. She felt warm all over, and she wanted to sleep. *I'd like to be back home in my nice, warm bed. I could turn over and go back to sleep because school will be canceled with all this snow. It's so nice and warm under these covers. I won't get up until noon.* Big flakes of snow covered Peggy, who sat on the ground with Regina in her arms. Regina slept soundly.

"We're in trouble, Larkin," said Donnie. "Peggy and Regina will freeze to death if we don't do something."

"What can I do?" asked Larkin helplessly.

"Use your power. Take us all home. Freezing to death here won't help anything."

"My uncle may trap us before I'm able to get us back."

"Do your best. No one will blame you if things don't work out."

"Okay. You get Regina's hand and I'll get Peggy's."

"Wait. Do not use your power."

"Did you say something?" asked a surprised Larkin, looking at Donnie through the falling snow.

"Not me," replied Donnie, looking around.

"Did you hear someone tell me not to use my power?"

"Yes, but I thought I was just imagining things. I'm so tired I can hardly think straight."

"Wait. Do not use your power. We will come. All will be well."

"Did you hear?" asked Larkin.

"Yeah."

"Do we wait?"

"That voice sounded kind—not what I imagine your uncle would sound like."

"Trust us. We are coming."

"You're right," said Larkin. "I trust that voice."

"I've never been so cold in all my life," muttered Donnie, as he stamped his feet and stared at Regina and Peggy sleeping in each other's arms. "I can't feel a thing in my feet or hands."

"Same here," agreed Larkin. "I'm so cold I'm not feeling much of anything anymore."

"Help better get here fast. I'm really worried about the girls." Donnie leaned down and brushed snow away from the faces of the two girls.

"We're here."

Both boys jumped, for they hadn't seen or heard anyone approach. What Donnie saw confused him. A dozen balls of glowing light danced in a circle around them. The lights were the size of large grapefruit, and each shone with a pure, white intensity.

"We have come. We are Luminee."

"Did you hear that?" asked Donnie, astonished that a ball of light could speak.

"I heard the words in my head, but I don't think I heard anything with my ears."

"I didn't either."

"We do not communicate in the same way you do. We will talk of that later. We must hurry. The storm is getting stronger, and it will be bitterly cold tonight. The girls already walk in the paths of darkness. We must get you to safety."

"Thanks," stammered Larkin.

"Each of you will be carried to our home. Do not fear. We will not drop you."

Luminee attached themselves to the shoulders of each traveler and lifted them a few feet above the ground. Nothing was said as the Luminee flew through the snow, which blew in horizontal sheets. More than a foot of snow lay on the ground. Donnie and Larkin couldn't see a thing, and they kept their heads bowed against the wind. Neither boy knew how far they traveled.

Suddenly, the wind stopped. The Luminee had brought the four friends to a warm cave where dozens of other Luminee hovered. Some darted close to the travelers, then retreated. It seemed they all wanted to study the strangers.

"*We must tend to the girls immediately. They are in danger.*"

"They'll be all right, won't they?" asked Larkin.

"*I think so, but one can never be certain. Now, I must go to them. Others will take care of you. Ask for anything you need.*"

One of the lights moved quickly away to the back of the cave where the girls lay beside a blazing fire. Other lights followed until a dozen Luminee hovered over each girl.

"*Will you join us at the fire?*" asked a Luminee, though neither Donnie or Larkin could tell which one. Both boys found it confusing not knowing which light was speaking to them.

"Thank you," said Larkin. "We're very cold."

"Do you have any food?" asked Donnie.

"*Yes. Food will be provided. Come.*"

The boys sat next to a fire warming themselves. The Luminee produced a soothing, warm drink, bread, butter, and honey, which the boys devoured greedily. Every so often, the boys glanced to the other fire, where the girls continued to lie quietly with the Luminee hovering six inches over them.

"Peggy and Regina are going to be okay, aren't they?" asked Donnie, after he finished eating.

A ball of light hovered closer to Donnie. "*We hope so, though they were close to death when we found you.*"

Donnie and Larkin stared at the girls. Peggy was stretched out on one side of the fire and Regina on the other. Every few minutes, one of the Luminee hovering over them drifted down and touched the body for a moment before floating back to its original position.

"What are they doing?" asked Larkin.

"*The girls have very little life-force. Without life-force, they will die as surely as they would have out in the blizzard. We are trying to restore their life-force.*"

"How?" asked Donnie, more worried than ever.

"By sharing our life-force with them."

"I don't understand."

"The Luminee you see hovering over the girls are transferring part of their life-force to the girls so the girls may live."

"That's amazing," murmured Donnie.

"It's also dangerous. When transferring the life-force, if a Luminee releases too much, that Luminee will die. The Luminee you see hovering over the girls have all volunteered."

"What happens when a Luminee dies?"

"The light would go out."

"If sharing the life-force is so dangerous, why are you doing it for strangers like us?" asked Larkin.

"We know why you are here. You are on a great quest to rid us of The Great Evil. You are willing to sacrifice your lives to achieve this goal. Can we do less to help you?"

"If you hadn't come to our aid, our quest would have failed. But, how do you come to live so near Gurnacht?" As Larkin spoke the name of Gurnacht, all the lights in the great cave dimmed and flickered, and Larkin heard a long, sorrowful wail.

"Please, do not mention that name again. The Great Evil has caused so much pain and suffering that we cannot bear to hear his name."

"I'm sorry," stammered Larkin. "I didn't know."

"Do not be unhappy. You were unaware."

"Who are you, and why are you here?" asked Donnie.

"We are the spirits of those who died on the Stairway to Darkness. We try to help the few who come this way—to warn them away if possible. We serve the good, though we may be the last to do so."

"Not true," interrupted Donnie. "The Jenfu work for good. They still fight the evil creatures of The Great Evil."

"We thought all the Jenfu had perished."

"Why do you stay here?" asked Larkin.

"We are unable to leave this plane of experience until The Great Evil is defeated. He keeps us trapped here, to torment us. We have had a brief experience of the next plane of existence. We long to reach that plane, but The Great Evil prevents us. He enjoys our sorrow and our loss. That is why we will sacrifice anything to help you."

"What do you mean by the next plane of existence?" asked Donnie, intrigued by what the glowing lights said.

"When our bodies died, as all bodies do, that was not the end of life. For some of us here, that was a great surprise. The spirit survives the body and moves

on. We do not know what the next plane will be like, or even if it will be the same for all of us. We sense that we move toward something better than the life we led on this planet. We have had only the briefest glimpse of the existence that awaits us, but all of us desire to travel to the next plane. To remain here in our present state is torture, and The Great Evil knows this and takes delight in our suffering."

The lights hovering over Peggy flickered. Donnie and Larkin watched as one ball of light touching Peggy blinked on and off twice, then winked out, like a light bulb being turned off. All the lights in the cave dimmed.

"What happened?" cried Larkin.

"One of our number has passed out of existence. She gave all her life-force to save your friend."

"An accident?"

"No. We were losing your friend to the darkness. So my friend gave up her existence to save your friend. She knew that you four might be our salvation. She sacrificed her life-force so the rest of us might have a chance to journey on. Such love is not often found."

The light hovering before the boys dimmed even more, and the words were filled with sadness and loss.

"What happens to her now?" asked Larkin.

"We do not know. Perhaps she ceases to be in any form—completely erased from the cycle of life. I hope that she has returned to the universal creative force. She deserves that."

"Look," cried Donnie, tugging Larkin's arm. "Peggy's sitting up." Donnie and Larkin dashed over to her.

"Where am I?" asked Peggy in a groggy voice.

"Safe," replied Larkin, who had dashed to her side and taken her in his arms. "It's so good to hear your voice."

"I feel so tired, and I had the worst dreams." Peggy shuddered, and Larkin pulled her closer.

"Me, too," said Regina.

"Regina," cried Donnie. "You're okay?"

"I think so, though I feel tired, as if I hadn't slept in a week."

"You will feel tired for some days. You have walked in darkness not meant for the living."

"Who said that?" asked Peggy, her eyes wide with surprise and looking around the room. "And what are all these lights?"

"The Luminee. They saved us. They don't speak like we do. You just hear their words in your head. But, you must be hungry. We'll

explain what we know while you eat, though we only know a little."

"I could eat a whole elephant," said Peggy.

"Me, too," agreed Regina.

Food appeared, just as it had for the boys, and the two girls ate greedily as the boys explained all that had happened since the girls fell asleep in the snowstorm.

"So we wouldn't be alive if it hadn't been for the Luminee?" asked Peggy, as she finished chewing a piece of bread.

"None of us would," replied Donnie. "We wouldn't have survived the storm."

"Do the Luminee think we have a chance of defeating you-know-who?"

"They haven't said, but their help has given us a chance to keep going."

"Then I think we should get on with it," said Peggy firmly. "No sense sitting here in a cave when we have a mission to complete."

"You must wait for the snow to stop. We will then lead you as far as we can, which is not far. The Great Evil has locked us in a small prison."

"Any help you can give us would be great," said Larkin. "We know little about what we face from here on."

"We can give you some help and some information. You have crossed the Plain of Tears, where we found you. You now have to climb the Peak of Sorrow to reach the castle."

"Oh, no," moaned Peggy. "Not another mountain to climb."

Regina began to hum quietly to herself. Peggy knew that Regina hated the thought of climbing another mountain as much as she did.

"The climb will not be as difficult as the Stairway to Darkness. There is a trail. But you will have to fight the cold and the snow."

"Where will the trail take us?" asked Larkin.

"To The Great Evil's lake. In the center of the lake is an island where his castle stands."

"How do we get to the island?" asked Donnie.

"We do not know."

"Oh, brother," muttered Peggy. "We're going to get to the edge of that lake and not be able to get across."

"One thing at a time, Peggy," said Donnie. "Let's get to the lake first, then we'll think of something. After all we've managed so far, a little lake isn't going to defeat us. Right Larkin?"

"Right."

"Okay. Sorry I was so negative. When do we start?"

"The snow is stopping, and there should be a few hours of clear weather for you to make a start. But snowstorms blow up quickly. Be prepared to take cover if a storm hits again."

"How can we thank you?" asked Larkin.

"Defeat The Great Evil and you release us from our prison. Do that and we will be eternally grateful. Now, before you go, we have one request."

"Anything you want," responded Peggy, as the others nodded in agreement.

"We have heard Regina humming. Her music is more beautiful than anything we ever heard. She has much music in her head. If she would permit, I would enter her mind and, in the blink of a bird's eye, learn all the music she carries there."

"Would it hurt?" asked Regina, her eyes wide.

"We would do nothing to hurt you. In fact, I could have done this without asking, and you would never have known. But, we never enter a mind without permission."

"What do you think, Peggy?"

"I think it would be fine, Regina."

"Okay," said Regina.

"Thank you, Regina. That didn't hurt, did it?"

"You're done?" exclaimed Regina.

"Yes. It takes only a moment. Thank you. We had no idea what a wealth of music you had stored in your memory. This music will bring us great joy. Your music, Regina, is the key to defeating The Great Evil. We might offer you one more service before you leave, if you would permit it."

"What's that?" asked Larkin.

"We could put all of Regina's music into each of your minds. It might help you to have this music. We have a premonition that this would be good."

"What do you think?" Larkin asked of the others.

"I think we should do it," said Peggy. The Luminee had saved her life, and anything they advised had her support.

"Agreed," said Donnie.

Larkin turned back to the light hovering a few feet from him. "We'd like to have Regina's music placed in our minds."

"That is good. The music is now in each of your minds, available to you should you need it."

The four travelers reluctantly left the warmth of the cave to face the icy blasts sweeping down off the mountain. The storm had dumped two feet of snow on the Plain of Tears, turning the world a brilliant white.

"I know we have to get on with this, but I hate to leave the Luminee," sighed Peggy, as she trudged behind Donnie, who led the way up the mountain path the Luminee showed them.

"Me too," replied Donnie. "When we first started on this mission, I was in it for myself–and my family. Now, it's much more than that. I'd hate to know that the Jenfu aren't free to roam the forests without worrying about wolves and vultures. I'd hate to disappoint the Luminee. I'd like to know they had moved to their next plane of existence. I'd also like to know that Earth will survive."

"You've changed a lot since we started."

"More than I would ever have believed possible. I used to think the only thing that counted was winning football games. That doesn't seem too important anymore."

"Will you still play football when we get back?"

"I think so. It's great fun. But I won't take it so seriously or believe that how I feel about myself depends on how many touchdown passes I throw."

Peggy smiled. *It's hard to believe that Donnie is saying this. He's grown so much during our trip. I respect him now. I consider him my friend–one of my best friends. Life is so strange, sometimes. Who would ever believe that Donnie could change so much? Of course, I'm sure I've changed too. It's just easier to see how someone else has changed.*

The travelers pushed on, moving slowly through the snow. Speed was impossible. It was not long before they were sweating under their warm clothing, even though a chill wind blew fiercely off the Peak of Sorrow.

"Which is worse?" gasped Peggy, when they stopped for a rest, "hiking through the desert or fighting the cold and snow?"

"The one you're doing at the moment is the worst," said Larkin, and he grinned.

Donnie nodded in agreement.

"How far to the lake?" asked Regina.

"The Luminee said about ten miles," responded Larkin, as he surveyed the path before them.

"We've come about two miles, I think," said Donnie. "If we keep moving, we should be there by early afternoon."

"There's much less snow here, too," observed Larkin.

After twenty minutes of walking, the ground was almost bare of snow, which lifted their spirits. Nobody noticed the clouds building high over the peaks, clouds that quickly turned dark and brooding.

An hour later, the clouds hung over the travelers, blocking out the sun. The wind, which had blown strongly when they first left the cave of the Luminee, died. A stifling quiet hung over the plodding group.

"What do you think?" Donnie asked Larkin, as he eyed the forbidding sky.

"I don't like it. This feels bad."

"My thought exactly. I think we're in for a serious storm."

"Should we find cover?" asked Peggy.

"The Luminee said cover was important if a storm blew up, and they know more about this land than we do," replied Larkin, as he looked around for shelter.

"Over there," cried Peggy, pointing to a half dozen trees huddled in a small depression on the side of the mountain.

"I don't see anything else," agreed Donnie. "Let's do it."

Big snowflakes began to fall as the travelers headed for the trees. The snow drifted lazily out of the sky. As the travelers reached the trees, the wind began to blow.

"Any chance of a fire?" asked Regina.

"Let's see if we can find some dead wood," said Donnie. "If we can get enough wood, I think I can get a fire going."

Dead limbs and branches littered the ground under the trees, and it didn't take long to collect a big pile of firewood. The trees and slight depression in the land offered some protection from the wind, and Donnie soon had a fire blazing.

"At least we won't freeze to death," said Donnie, as the fire crackled merrily.

"How long will we be stuck here?" asked Peggy.

"Hard to say. I hope this storm won't last too long. The more snow that falls, the harder the walking."

Donnie's hopes proved vain. The snow fell thick and fast for three hours as the wind moaned through the bare limbs of the trees overhead. When the snow stopped, more than a foot covered the ground, with drifts of four feet in some places.

"Most of the time, I like to see snow," said Peggy, as she looked out from beside the fire that was fast burning out. "But I could have done without this."

"Me too," agreed Regina.

"Shall we get on with it?" asked Donnie.

"Might as well. Besides, we're getting close to the end," said Peggy.

"You okay, Larkin?" asked Donnie, who observed Larkin standing quietly, looking toward the snow-covered path they would be returning to.

"I'm worried that I haven't had a vision yet. I'm wondering when it will happen and what it will be."

"That worries you?" asked Peggy, as she took his arm and squeezed it gently.

"A little. I hope I can do as well as you all have done."

"I'm not sure we did particularly well," observed Donnie. "Help from others saved each of us. When your turn comes, we'll be there, right?" Donnie looked at Peggy and Regina.

"Right," said the girls in unison.

Larkin smiled. "It helps to know I have friends backing me up. Okay, let's get going. We still have seven or eight miles to walk, and it isn't going to be easy."

The travelers plowed their way back to the path, which they could barely make out in the snow, and began to plod slowly up the mountain.

CHAPTER 12

"I have to rest," said Peggy. She had been following Donnie, who was breaking trail. Each step through the heavy, wet snow required great effort, exhausting her.

"We all need a break," puffed Donnie. His face was bathed in sweat, and his breath came in deep gasps.

"You okay?" Larkin asked Donnie.

"Yes, but this is hard work. Harder than any football practice I ever went through. In fact, I'd give a lot to be at football practice right now." Donnie smiled briefly.

Regina hummed a tune to herself.

"Let's take ten minutes," said Donnie, "then see if we can get a little farther along. I'd like to reach the lake before night, but we're moving so slowly, I don't know if we can."

Ten minutes later, the weary travelers were grunting and groaning as they wearily forced their legs through the deep snow. No one spoke. Peggy felt her body rebelling. *Can I take one more step? There's got to be a limit somewhere. I don't want to be a quitter, though. Donnie keeps going. Larkin hasn't complained, and I know he's suffering. Just look at him. Head bowed. But, he keeps on going. Regina keeps going, too. I can keep going. Heck, we're barely moving as it is. A snail would leave us in his dust. That's a funny picture. I could almost laugh.*

"How much farther?" panted Peggy when the group stopped for their next rest.

"At least five miles," said Donnie glumly.

"I could use a real rest," observed Larkin.

"Me too," said Regina. "I don't know if I can go much farther."

Donnie looked around. "I'd like to stop, but there's no cover here. As soon as I spot a place where we can camp, we'll stop. Tonight will be cold, and we have to have shelter, or we'll freeze."

Peggy woke from her mind-numbing fatigue at Donnie's words. "We're in trouble, aren't we–like, I mean big trouble."

"I haven't seen a tree since we left our fire. There doesn't seem to be anyplace where we can get out of the wind and the cold. If we don't find something before night, well...."

"Okay, guys, come on," said Peggy emphatically. "Let's keep walking. We can't stop now. We're too close."

The travelers struggled forward for a hundred yards to a spot where the trail bent around an outcropping of rock. The left side of the trail dropped off into a deep chasm. To the right, a cliff rose hundreds of feet in the air.

"Look at the snow," said Larkin. A six-foot-high drift blocked the trail.

"What now?" asked Peggy, frustration in her voice.

Donnie stood looking at the drift before answering. "I'll try to force my way through. Maybe I can make a trail you can follow." He spoke with dogged determination, though fatigue glazed his eyes.

Peggy noticed that Donnie's shoulders sagged. He looked worn out. "Can you do that?"

"I don't know, but I have to try. We've come too far to be defeated by a little snow. Wait here."

Donnie plowed into the drift, using his arms and hands to shove snow aside. He stayed close to the cliff wall. One step too far to the left and he would plunge hundreds of feet to his death. He disappeared around the corner of the trail. Peggy, Regina, and Larkin stood watching, hoping desperately that he would be successful. Only a few minutes elapsed before Donnie returned, a smile on his face.

"The drift covers just this spot. Once I got around the corner, I found hardly any snow on the ground. Walking will be easy the rest of the way. Come on."

Wading through the drift taxed Peggy's last reserves of energy. Donnie gave her his hand and helped pull her through the worst spot. On the other side of the drift, only a few inches of snow lay on the ground.

"I like this much better," said Larkin.

"Maybe we can make it to the lake now," said Regina.

"I think so," said Donnie. "I know we're all tired, but I think we should push to the lake no matter what."

Two hours later, as darkness began to fall, the weary travelers stood on the edge of Gurnacht's lake. The lake was a perfect circle and a mile across. Mists rose off the water. In the center of the lake stood a low island with a massive, black castle thrusting up into the dark sky. Not a light shone anywhere in the castle.

"Spooky," murmured Donnie as he stared at the castle.

"I wonder what my uncle is doing," said Larkin.

"Probably having a nice dinner in front of a warm fire," said Peggy, as she shivered, "which is more than we're going to have."

"Hey, this water is warm," called Regina, who had walked down to the lake's edge.

"Strange," said Donnie, as he put his hand into the water. "This water should be ice cold."

"At least we won't freeze tonight," said Peggy. "We can sleep next to the lake and stay warm."

"That's good, since I don't see any wood for a fire."

"How are we going to get to the castle?" asked Peggy.

"I don't know," replied Larkin. "Getting to the island could be the biggest obstacle we face. Ideas anyone?"

"You know," said Donnie thoughtfully, "with the water as warm as it is, we could swim to the island. It's not more than a quarter of a mile."

"I can't swim," said Regina.

"Not a problem, Regina," said Donnie, and he smiled. "Let's pitch camp."

After a light supper of bread and butter that the Luminee had given them, the travelers sat on the edge of the lake and stared into the darkness. They couldn't see the castle, though they felt its malevolent presence.

"It's not as cold sitting here as I thought it would be," said Peggy.

"Not half bad," agreed Larkin, "especially after the past couple of days."

"I still don't see how I'm going to get to the island," said Regina. "I can't walk on water."

"Could we build a raft?" asked Peggy.

"That would take too long," said Donnie, "even if we had the materials to work with, which we don't. I didn't see any trees on the shore of the lake when we first got here. I was thinking about some sort of raft—or even just using a log to hang onto as we floated over to the island."

"But you have an idea, right?"

"If Regina will trust me, I can swim her across. I took a lifesaving course a couple of years ago. There's a real easy way for me to swim Regina over to the island. The main thing is that she doesn't get scared and try to fight me. Will you trust me, Regina?"

"You're my friend, Donnie. I'll trust you." Regina began to hum a little tune, and Peggy knew she was scared.

"Well, I'm going to try to get some sleep. I'm beat," said Donnie, as he stretched out in his sleeping bag.

Peggy stretched out in her sleeping bag, too, though she didn't think she could get to sleep, even though she was more tired than she had ever been in her life. Every muscle ached. Normally, she would have been asleep in minutes, but she was too tired to close her eyes. Her mind whirled.

We've reached the end of our journey—finally. Now what? We've faced all sorts of dangers, but now it seems like we're facing the greatest danger of all. I don't like the idea of swimming to the island, even in warm water. Surely Gurnacht will just laugh at us and then...what? Something too horrible to even think about. What if he kills us? I want to see Grandma again, to walk to school and see my friends, to feel the warm summer sun on my face. I don't want to die. And that lake. I've got a bad feeling about the lake. "Donnie?" she whispered.

"Yes?"

"Something about the lake scares me."

"Don't worry. It's not far to the island. You'll make it."

"It's not the distance that worries me. I've got a feeling that's bugging me. There's something evil about this water. I don't know what, but it scares me."

"I know."

"You know?"

"I feel the same thing."

"And you're still going to swim it?"

"I can't see any other way. The main thing is to get Regina and Larkin to the castle."

"Aren't you afraid?"

"Sure, but we've come so far, and so many people are counting on us. I can't quit now."

"I know what you mean."

"Look, Peggy, I don't know what tomorrow will bring, but I want you to know that I think you're just about the neatest person I've ever met. I hope we'll always be friends."

"We will, Donnie." Peggy smiled to herself. *Who would ever have thought I'd be talking to Donnie Himler like this? Carla and Kristi would never believe me in a million years. Heck, I can't believe it myself.*

"There's something else I've been thinking about," said Donnie slowly.

"What's that?"

"If something happens to me, you need to take charge."

"Nothing's going to happen to you. Don't talk like that."

"I hope you're right, but we have to be prepared. A team always has a backup quarterback. You need to take over if I can't lead. Get Regina and Larkin into the castle. That's where the game will be won. Promise?"

"Okay, I promise. But you better not let anything happen to yourself. I'd be really mad."

Donnie laughed quietly. "I'm sure I wouldn't be happy, either. Now, we better get some sleep."

Peggy couldn't sleep for a long time, and she watched the strange stars swing across the sky overhead. *I know why I can't sleep. The fear of swimming to the island won't go away. I don't know what it is, but something bad is in that water, and we aren't going to escape it, either. Oh, how I'd like to be in my own bed.*

"Wake up, Peggy," murmured Donnie, as he gently shook her. "Time for a swim."

"But it's not even light yet."

"I know. I don't want Gurnacht to see us coming."

"Oh, right." Peggy couldn't remember going to sleep. She didn't feel rested. Bad dreams had run through her mind most of the night. Her legs still ached.

"We'll leave our packs here," said Donnie. "We won't need them, and they'd only weigh us down as we swim."

"What about our coats?" asked Peggy.

"Leave them. Too heavy."

When everyone was ready, they waded into the warm water, walking out into the gray-white mists that covered the water.

"This feels good," said Peggy. "It's the warmest I've been since the cave of the Luminee."

Fifty feet into the water, the bottom dropped away and they began to swim. They swam slowly, using the breaststroke to conserve energy and to stay close together. Regina was on her back in front of Donnie, with her hands gripping his shoulders, her arms straight.

"You okay, Regina?" puffed Larkin.

"A little scared." She held her mouth high out of the water.

"Don't worry, Regina," said Donnie. "I won't let anything happen to you." He continued to swim with strong, even strokes.

"The water's getting warmer," sputtered Peggy.

"I feel it," said Larkin.

"Don't worry," said Donnie. "It'll have to get a whole lot warmer to be a problem. Besides, we're over half way."

I hope Donnie knows what he's doing. If this water gets much hotter, I don't see how we can keep going. I can't stand the thought of turning around—not now, not this close.

They continued to swim through the mist toward the island and the castle, which they couldn't see. All was silent except for the small, water sounds they made as they swam. The mist turned whiter as the morning light increased. Suddenly, the mist parted, and the swimmers saw the island a hundred yards in front of them.

"Almost there," puffed Donnie.

Peggy felt her feet touch the lake bottom. The fear of something evil in the lake that she had felt the night before, and which had dogged her as they swam, began to drain away. *I was wrong. Nothing happened.*

"We made it," Peggy cried happily to her friends.

"Did you ever doubt," replied Donnie, a grin on his face.

"I'm glad that's over," sighed Regina.

"Let's get out of the water," said Larkin. He began to push toward the shore, only twenty yards away. The others followed, with Donnie bringing up the rear.

An ear-splitting roar halted them. Peggy turned to see all her fears about the lake confirmed. A massive green beast towered over Donnie. The beast had the head of a giant lizard. Red eyes peered out from under heavy lids, and a forked tongue darted from its mouth. Arrow-like spines projected from the beast's back, running down a long tail that thrashed the water into a white foam. It looked like a Tyrannosaurus Rex, though not so large and with a much smaller head.

"Get out of here," screamed Donnie, as he turned to face the beast, which hesitated for a moment, perhaps surprised that such a small prey would turn to fight.

"Come on," screamed Peggy, grabbing Larkin and Regina and pulling them to dry land.

The beast roared again, then grabbed Donnie with its small hands and retreated into the lake. Peggy stood with the others on the shore and watched as the creature waded back into the deep water, roughly clutching Donnie, who struggled in vain. The beast ducked under the water and disappeared.

"No," Peggy wailed. "This can't be happening. I won't let it

happen. This isn't fair. Do something, Larkin. Save Donnie. Use your power!"

"I can't," mumbled Larkin. "I tried."

"What do you mean, you can't?"

"On my uncle's island, I have no power. It's like I'm in a thick oil that has paralyzed my power. His power is so great that mine is completely wiped out. I can't help Donnie."

Peggy began to cry, from frustration, from anger at the beast, and from the searing loss of Donnie. *Donnie kept me going—saved my life. We'd never have gotten this far without him. He should have lived. I'm expendable. He's not. I can't believe he's gone.*

Larkin put one arm about her and held her close. He held Regina in his other arm.

"He was my friend," Regina sobbed. "I don't have many friends."

"He was my friend, too," said Larkin as tears rolled down his cheeks. "Without him, we wouldn't be here."

Suddenly, Peggy realized what she had to do. "Come on," she ordered as she wiped the tears from her eyes with a wet sleeve. "We'll cry later, but now we have work to do. Your uncle is going to pay for this."

Regina and Larkin stared at Peggy for a moment, then wiped their tears away.

"You're right," said Larkin.

"Let's go," ordered Peggy. "To the castle."

They walked up the wide, pebbled beach toward the black castle, now fully visible in the morning light. It looked cold and evil, and though Peggy knew what she had to do, she felt the evil wrap itself around her and try to overcome her. She stamped her feet as she marched toward the castle, and her anger flamed. *There's no way I'm going to back down now. I'm not going to give in to this evil, either. I know what's right, and this isn't. Nothing about this Gurnacht is right.*

The polished black marble walls of the castle loomed over them. Peggy saw no windows. Black turrets and spires thrust thousands of feet into the air.

"Look," gasped Regina, as she shrunk against Peggy. Sitting on the battlements of the castle were black vultures. They seemed unaware of the three travelers—or uninterested—as they perched unmoving as statues.

"How do we get into the castle?" asked Peggy.

"Find a door," said Larkin, as he began walking around the castle.

Thirty minutes later, they found a small door, the only break in the wall they had seen.

"Do we knock or just go in?" asked Peggy grimly. Her eyes flashed as she spoke. She would see Donnie avenged if it was the last thing she did.

Larkin walked up to the door and pushed on it. The door swung open soundlessly. After they entered, the door swung firmly shut behind them, and Peggy knew that if they tried to leave, the door wouldn't open. The three travelers walked down a long, narrow tunnel that opened into a great hall. The hall was far larger than any cathedral ever built on Earth.

Peggy gasped as her eyes swept the room. Two rows of black, marble columns, with carved serpents winding round them, rose to a ceiling lost in murky darkness. Peggy couldn't see the walls of the hall, also lost in gloomy shadows. Between the marble columns stood great thrones of gold, marble, silver, and rare woods polished to a brilliant sheen. All reflected the blackness that permeated the room. The columns marched to the far end of the hall, where torches blazed around a massive throne—larger than all the others in the room—carved from black marble. A figure sat on the throne, but he seemed oblivious to the three travelers. As they stepped into the mammoth room, a portcullis silently fell behind them, cutting off any retreat down the corridor they had come through.

Trapped. Well, we came here to have it out with Gurnacht. It doesn't matter whether the doors are locked or not, so long as we get to him. He's going to pay for Donnie's death. "Come on," said Peggy. "We have business with that man."

"Easy, Peggy," whispered Larkin. "He has powers you can't even imagine."

"We'll find out what kind of power he has," she snapped as she strode angrily toward the throne.

As the three friends marched toward the throne, their sense of evil increased. Peggy felt as though she were wading through a thick, sticky lake of evil that clung to every part of her body, that no such thing as good could possibly exist anywhere in the universe, that evil was the reason for all creation, and that the center of all that evil sat on the black throne.

When Peggy stood ten feet from the throne, Gurnacht slowly raised his head and stared at the three friends. Peggy sensed a man who had lived centuries rather than decades. His withered body bent

in upon itself many times. His thin, white hair fell in wisps about his shoulders. A thousand wrinkles lined his face.

When Peggy looked into Gurnacht's face, his eyes held her with a vice-like grip. They were eyes ravaged by all the imaginable and unimaginable evil in all the universes ever created. She saw the evil of a million wars, the evil of a billion murders, the evil of a trillion jealousies. In those eyes Peggy saw evil so horrible that she shook with uncontrollable fear.

"Welcome, my friends. I've not had visitors in many ages. I didn't expect you, or I would have prepared a more fitting welcome."

"I'm sure you would have," said Larkin quietly as he stared at his uncle.

"Nephew. So good of you to come. I've looked forward to meeting you. But," he shrugged, "your father never saw fit to introduce us. More's the pity. I sense great potential in you." His eyes glittered coldly, maliciously. "Now, to have you here, all to myself...why, this is a surprise I never expected. Your father knows you are here, by the way, and it disturbs him greatly. That gives me infinite pleasure. Your presence here will disturb him even more as time goes on."

Gurnacht laughed, and the sound froze Peggy's soul. She had never heard a more depraved sound in her life.

Larkin stared up at Gurnacht. "You've done great evil to many people, and you mean to do more. I can't let that happen."

"Oh, my, you can't let that happen?" wheezed Gurnacht. "How are you going to stop me, you little fool?"

"I'm not sure, yet," Larkin stammered, and he dropped his eyes.

"Not sure? That doesn't sound promising, nephew. Did you bring your friends to help you?" His eyes turned to Peggy and Regina, who gripped Peggy's hand and stared at the floor. "Foolish children. Didn't my nephew tell you what danger you faced? Didn't he tell you of my power? Didn't he tell you that I have tortures that will wrack your bodies with unimaginable pain? I see that you have suffered on your march here. That suffering will seem a balm after you experience the pain I inflict. Didn't he tell you I can keep you alive for centuries as I enjoy the pleasure of your pain? Didn't he tell you any of this?"

"He told us," cried Peggy. "We came anyway. You have much to answer for, including the death of our friend. We're going to put an end to your evil ways."

"Oh, my dear, and how do you intend to put an end to my evil ways?" sneered Gurnacht contemptuously.

Peggy glared at the evil apparition on the throne and said nothing. She felt the evil in the room strengthen and resonate to her anger, but she didn't care.

Gurnacht turned his eyes to Regina. "And you, my dear, what will you do to defeat me? Why, if I don't mistake, you don't even have a complete mind."

Regina kept her eyes on the floor and said nothing, but Peggy felt her tremble.

"As I thought," Gurnacht said, and turned his attention back to Larkin. "Nephew, I admire your determination. A noble attribute. I admire your perseverance, however misguided. You have done exceedingly well to get here at all. That you reached my castle surprises me. I admit it. You have great potential, greater potential, perhaps, than even I had at your age. Let me show you."

The air shimmered and brightened as Gurnacht led Larkin into his vision.

CHAPTER 13

Larkin gasped. He stood on the tallest castle turrets, which soared far above the lake, above the planet, seemingly above all creation. Spread out before his eyes he saw every universe ever created. With a blink of his mind, he could focus on any universe, or any galaxy in that universe, or any planetary system in that galaxy, or any planet in that system. Never had Larkin experienced such a euphoric feeling of power and omnipotence. He felt that it would take so little for him to control all that he saw, to rule with a kind but firm hand. To rule—a beloved king—down untold centuries, dispensing justice and goodness to all who worshipped him.

As Larkin stared, he saw movement among the universes. Some slid slowly toward others and engulfed them, like a large bass might gobble up a minnow, and where there had once been two universes, only one remained. Larkin stared more intently, and he realized that some universes were being attacked by other universes. It appeared that all creation was engaged in a massive battle. He turned to Gurnacht with a questioning look.

"Ah, so you see," leered Gurnacht. "Good. You have the power. What you see is the survival of the fittest on the grandest possible scale. Those universes that are strong and powerful take the place of those universes that are weak and have nothing to offer to the progression of creation. It is the way of all life."

Larkin stared at the vast array of universes, and then he saw a small universe that was Peggy's universe and the home of Earth. He saw another universe sliding toward it, a threatening, black mass three times the size of Peggy's universe.

"You're destroying my father's work."

"Survival of the fittest," replied Gurnacht. "Your father always was weak, always wove weak creations. Surely, you can't expect such creations to last—not when there's a weaver of my stature creating greater works?"

"Why do you destroy my father's work? Why can't your work exist alongside my father's?"

"Times change. I've decided that only the best creations—the

strongest creations–will survive. Since my work is the best, as you can easily see, only it will survive."

"Why have you shown me this?" asked Larkin coldly.

"I'm getting old. Oh, I still have centuries before my time ends, but I need to train someone to carry on after I am gone. Until now, I've found no one with the potential to carry on my work. Then you come to me–of your own accord, even–and I see that you carry the power within to be a worthy successor to my throne. I offer you that opportunity–an opportunity to rule all creation."

"You would have me weave evil?"

"Evil? That's a harsh word, nephew. I weave only what is strong, only what will survive. Is that wrong?" He looked at Larkin benignly, a faint smile playing about his lips.

"You would destroy the Earth, where there is so much beauty. Why can't it survive and grow?"

"Weak is not beautiful," snarled Gurnacht, momentarily losing his composure. "You must learn that beauty is only in strength. Look at all these creations. In each one, the strong survive and the weak die. That's the lesson I have learned, and it's a lesson you will learn as my assistant."

"I haven't agreed to be your assistant," said Larkin calmly.

"Oh, but you will, I think. Consider the power you will have, power such as no other weaver excepting myself has ever wielded. Think what you could weave. Think of the untold universes you could bring to life. I will teach you things your father would never mention. We will stand astride all creation like two giants, and all will bow down and worship us. Think of it. Think, too, of the alternative to my offer." Gurnacht's eyes glittered as he stared out across the universes.

"I want to follow in my father's footsteps," said Larkin.

"And see your puny creations destroyed? Why do that? Surely it's better to see your creations survive and multiply, isn't it?"

Larkin felt his thinking become less clear, as if he had been looking at a beautiful landscape and a light fog had blown in, obscuring it. What had seemed logical moments before no longer seemed quite so certain. If he were strong and powerful, he could do much good. "What you say begins to make more sense."

"Of course it makes sense, my boy," said Gurnacht, putting his hand lightly, almost affectionately, on Larkin's shoulder. "You're too smart not to see the wisdom of my offer. The two of us will create

universes undreamed of with our combined power, power that will make us veritable gods."

"He's under Gurnacht's spell," cried Peggy, as she stood watching the vision with Regina. "We have to do something."

"We could go to him," said Regina.

"I don't know what we'll be able to do, but we're not doing any good here. We might as well try," said Peggy, determination in her voice. "We can't let Larkin be taken in by Gurnacht."

"All for one and one for all, right?" asked Regina, though her lower lip trembled as she spoke, and her eyes were wide with fear.

"Right," agreed Peggy. "Let's go!"

The two friends clasped hands and stepped into Larkin's vision.

"Who are you?" asked Larkin, a puzzled look on his face.

"No one," growled Gurnacht. "I'll remove them."

"Larkin," yelled Peggy, "don't you remember? We came from Earth to save my universe."

"Don't listen to this nonsense," snarled Gurnacht. "We have much work to do together, you and I. We don't have time for a child's drivel."

"You're not going to work for him, are you?" cried Peggy. "He's the one who's destroying your father's work."

"My father's work?" Larkin shook his head as if coming out of a deep sleep. "Of course, now I remember why I came here."

Gurnacht glared at the two girls and slowly removed his hand from Larkin's shoulder. "Too bad, you fool. Now you will suffer along with these other meddling children, suffer until you see the wisdom of my offer. And I shall let your father know at regular intervals just how much you suffer, will even let your father feel some of your suffering, but only the worst pains, of course." Gurnacht laughed, a dark, ugly sound. "Yes, that will bring me great pleasure, though I think it will bring little pleasure to your father. He's as much a fool as you are, nephew."

"We'll see who's the fool," replied Larkin, glaring at Gurnacht.

"As for you," Gurnacht growled, and turned his cold eyes on Peggy, "I despise people who meddle in my affairs, which you have just done."

The vision shimmered into nothingness, and they stood before Gurnacht's throne in the black hall. Gurnacht loomed over the travelers. He seemed to grow in stature, and a powerful force surrounded him, a force that Peggy felt was evil beyond anything she

ever could have imagined. She shuddered as Gurnacht's evil spread a dark cloud of pain, envy, jealousy, and anger over the room. The walls seemed to resonate to the evil, amplifying and intensifying it.

"No," screamed Peggy. "You can't do this to us. We won't allow it."

"Won't allow it?" thundered Gurnacht, his voice a hurricane of sound blasting out of the black shadow he had become. "You no longer have anything to say about your life. You're mine. You shall suffer for your audacity as no one has ever suffered before, and your suffering shall last for centuries."

Bolts of lightning flashed from the black cloud, cleaving the brooding darkness that hung over the hall. Evil whirled about the room, saturated the air, threatened to smother the three friends. As Peggy quailed before Gurnacht and thought that all was lost, she heard a small sound cutting through the suffocating quagmire of evil, like a silver trout slicing through the water of a stream. She looked to her right and saw Regina, her eyes wide with fear, humming a tune.

"Stop that noise," exploded Gurnacht, now a massive black shadow reaching to the ceiling of the great hall. But the shadow wavered with each note Regina hummed.

"No, Regina, don't stop," Larkin's voice was choked, as if he were waking from a deep sleep. "Sing. Sing Peggy. Sing Beethoven's *Ode to Joy*. The Luminee put the music in our minds. Sing." The three small voices joined in the magnificent *Ode to Joy* that ends Beethoven's Ninth Symphony. As they sang, Peggy noticed that the room seemed less black, less evil.

"I command you to stop," roared Gurnacht, his swollen face looming out of the dark cloud, his eyes flashing lightning bolts of anger that ricocheted about the throne room.

"Make us," yelled Larkin. "Let your mind release all the music you've ever heard, Regina. Music. Let it out."

Suddenly, Peggy heard music echoing through the room—Mozart, Bach, Beethoven, the Beatles and countless other composers. The walls of the castle resonated to the music, amplified it into great crescendos of sound, all in tune, no melody lost in a sea of harmony.

"This is the beauty of my father's creation," yelled Larkin to Gurnacht, no longer a powerful shadow of darkness but an ashen faced, withered shell of a man cringing on his throne. "You would destroy this beauty, but that won't happen now," he called triumphantly as the music continued to reverberate through the hall.

A large chunk of black marble crashed to the floor next to Gurnacht's throne. "Get out of here," yelled Larkin to Peggy. "I'll finish with Gurnacht. Run. The doors will be open."

"Not without you," cried Peggy, and grabbed Larkin's hand.

"Don't argue. I must finish this. If I don't stay, he might escape. Now, go. The music is destroying the castle."

Peggy released Larkin's hand, grabbed Regina's, and ran across the throne room to the tunnel they had first entered. Great chunks of marble crashed from the ceiling as they ran. As Larkin had promised, the iron portcullis was no longer down, and the door at the end of the tunnel stood open to the outside. The girls raced down the tunnel and out into the morning mist. Loud rumblings, like a thousand noisy buses starting up, sounded within the castle.

"Let's get as far away as we can," cried Peggy, and she led Regina down to the edge of the water, where they stood and watched the black castle begin to fall in upon itself. Gray plumes of dust shot into the air as the turrets collapsed.

"Where's Larkin?" cried Regina.

"I don't know. If he doesn't hurry, he won't make it."

As Peggy spoke, the high black walls fell back with the thunderous roar of a thousand crashing waves, leaving only a massive pile of shattered black marble. Peggy stared at the pile of rubble in stunned silence, unable to believe what she had just seen.

"He's not coming out, is he?' asked Regina after a few moments of silence.

"No," said Peggy, and tears streamed down her face.

"I liked Larkin. I wish he didn't have to die." Regina began to cry along with Peggy. When the first wave of crying was over, Regina looked at Peggy. "What will we do?"

"I don't know. All I can think about are Larkin and Donnie. I miss them so much, and I'm never going to see them again."

"Look, Peggy. Look," cried Regina.

When Peggy looked up, she saw a host of lights streaming across the lake toward them. "The Luminee. They're free. Donnie would be so pleased."

The lights flashed up to the girls and swirled around them in a joyous dance. Both girls heard the words *free* and *thank you* repeated over and over. Without warning, the host of Luminee shot up into the sky in a long stream of light, like a roman candle, disappearing without a trace in the blue sky as they streaked heavenward.

"Gurnacht must be dead," murmured Peggy.

The girls quietly sat by the lake's edge for some time, each wrapped in her thoughts. *We suffered so much to reach this moment, and now I can't celebrate. Was the sacrifice worth it? I guess so. To see the Luminee free was wonderful. To know that Earth will be safe is even better. But what about Donnie and Larkin? They're dead. They made it possible to defeat Gurnacht, but they can't celebrate, and I can't either. I hurt too much.*

"What will we do now?"

"I don't know, Regina. I can't swim you across the lake like Donnie did. Even if I could, I don't think the two of us could ever get back to the Jenfu. We'd never be able to climb down the Stairway to Darkness by ourselves."

"Will we die here?"

"I think so, Regina," sighed Peggy, and the two girls lapsed into silence.

"I'm not scared, Peggy."

"I'm not either. It will be good not to hurt so much inside."

"Thanks for being my friend, Peggy." Regina paused for a moment and stared out across the water before continuing. "So how long will it take—to die, I mean?"

"I don't know. We don't have any food, but we have water. I guess we can last a long time."

"I'd rather get it over with quickly."

"Me, too. I wish we'd stayed in the castle with Larkin."

The day brightened, and directly above them, the girls could see a blue sky and a bright sun.

"Why so sad?" boomed a deep voice.

Both girls scrambled to their feet. Behind them stood a tall man with long white hair and pale blue eyes. He smiled kindly on them, and his eyes sparkled with wisdom, intelligence, and love.

"Who are you?" asked Peggy suspiciously, though nothing about the stranger made her fear him. Larkin hadn't mentioned anything about Gurnacht having servants.

"A friend to those who would have a friend," replied the stranger. "But again, I ask why so sad?"

"Our two best friends died today."

"That's good reason to be sad. Yet you have accomplished a mighty deed here," he said, and motioned toward the remains of the castle. "You've defeated Gurnacht from the looks of his castle."

"Yes, we did. But it's hard to be happy when good friends die,

even in a good cause." Tears came to Peggy's eyes, though she didn't want to cry in front of a stranger.

"Tell me who died and how they died," said the stranger as he sat down between the girls.

Peggy quickly told the tale, though the stranger kept interrupting to ask for details. Peggy told him everything, from the time they left Earth to the moment the castle collapsed.

"And your friend, Larkin, stayed in the castle, even though he knew it was collapsing?"

"He said he had to stay to make sure Gurnacht was destroyed. He used the music that the Luminee put in his mind, Earth's music, to destroy Gurnacht. I wanted Larkin to leave, but he wouldn't."

"Music is one of the most powerful forces in all creation. Gurnacht never realized that. He always thought music was for weaklings. For all his knowledge, he was so blind."

The tall stranger reached out to the girls and put an arm around each of them, and they felt a healing power flow into them. The sadness that had weighed on their hearts was not so strong.

"Who are you?" questioned Peggy, wonder in her eyes.

"I am Saresto, Larkin's father," said the man softly. "You have done a mighty deed and a good deed here."

"Isn't there something you can do for Larkin and Donnie?" pleaded Peggy. "Larkin said you were the greatest world weaver ever."

"What would you have me do—bring the dead back to life?"

Peggy dropped her eyes. "Of course not. That's impossible. I just thought...." *Thought what? I don't know. Somehow, when he said he was Larkin's father, I thought he might make everything okay. Sometimes I'm so dumb I can't believe it.*

"Is there nothing else you would have me do?"

"Could take us back home? If that wouldn't be too much trouble?"

"Too much trouble? My dear girls, your deed has earned the thanks of all creation. Nothing you request would be too much trouble." He smiled warmly at Peggy.

"Could you take us to the Jenfu first?" broke in Regina.

"Of course. That would take but a moment."

"I'd like to tell them that Gurnacht is dead. Perhaps I could sing them a song before we leave. Would that be okay, Peggy?"

"Sure, Regina. I'd like to see Shu and Yolan before we go." *I still*

feel so down. I wonder if I'll ever be happy again? But how can I after what's happened?

The air shimmered, and Peggy found herself in the Jenfu cave sitting next to Shu, who had a look of surprise on his face. "Peggy," he said. "I never thought to see you again. And Regina. Welcome. But who is with you?"

"This is Larkin's father, Saresto. He brought us here."

Shu stood and bowed deeply to Saresto. "Welcome, Master. You honor us with your presence."

"I'm pleased to meet you, Shu. I've heard good things about you and your people. You have fought many years against great evil. The greater part of that evil is destroyed. You and your people may now live in peace and freedom, and you will no longer have to hide in caves."

"This is wonderful news," exclaimed Shu. "I never thought to see this day. But," and he turned with a questioning look to Peggy, "where are Donnie and Larkin?"

Peggy quickly told the story, and Shu looked grave when he heard how the two boys died.

Regina walked away to join a group of Jenfu. When she started singing, a crowd quickly gathered about her. Saresto turned and watched Regina sing.

"Peggy," whispered Shu. "Have you asked Saresto to return Larkin and Donnie to you?"

"Well, sort of, I guess."

Shu looked hard at her. "Did you ask?"

"No, not really. I didn't believe he could bring the dead back to life."

"Saresto is the greatest world weaver ever to live. He has powers that go beyond anything you can possibly imagine. If you want to see Donnie and Larkin again, you must ask him, and you must believe."

Peggy looked dubious. "Can he really bring them back from the dead?"

"If you believe." *How can I believe in the impossible? No one can bring the dead back to life. Yet, Shu believes, and he's a wise man. Where will I get my belief, for that's what Shu says I need.*

Peggy walked hesitantly over to Saresto, who stood away from the crowd, listening to Regina sing. "Sir," she said, "will you please bring back Larkin and Donnie?"

"Do you believe?" he asked.

"Yes."

The weaver turned his eyes on Peggy, and she felt him look into her soul, into parts of her soul where she seldom had the courage to look. Then he smiled, a smile that was like the rising sun on a spring morning when all the earth celebrates the rebirth of another year. "Do you think they have earned another chance at life?"

"Oh, yes," cried Peggy, and she knelt before Saresto. "Surely they have, sir. Surely."

"Do you believe I have the power to return them to you?" His blue eyes again stared into Peggy's soul, and she knew that she could hide nothing from him.

"Yes."

Saresto closed his eyes and knit his brow in concentration. The atmosphere shimmered, and the images of Larkin and Donnie began to form in the undulating light, and the two boys stepped forward.

"Father," cried Larkin, and raced into his arms. "But I thought...."

"Don't think about it," murmured his father. "Later, you will want to explore the dreams you walked in, but not now. Now is for celebration."

"Donnie," squealed Peggy, and threw her arms about him in a great bear hug.

"How...?" exclaimed Donnie, wonder in his eyes. "I was in the lake and there was a monster and I...."

"Don't think of that," said Larkin's father gently. "That will be as a distant dream that won't trouble you anymore."

"Gurnacht is dead," cried Peggy, her eyes shinning with joy.

"Gurnacht is dead?" repeated Donnie, looking disoriented. "Then we succeeded?"

"Yes," said Larkin's father. "You have all done well, extraordinarily well, especially you, my son."

"I couldn't have done it without my friends," said Larkin.

"I know. They have all done well, and, I think, grown in the process. Now, I'm sure your friends want to return home. I will see to it, with their permission."

"What will you do, Larkin?" asked Peggy, grabbing his hand.

Larkin stood quietly for a moment, considering. "Father, with your permission, I'd like to return to Earth with my friends. I think I could learn a lot there."

"I think you could. That will be fine, for a while. But Gurnacht

has left much evil that we will need to deal with, and I will require your help. When the time comes, you will return to me, and we will proceed with your apprenticeship as a world weaver. You passed a great test when you refused Gurnacht's offer of power. You will become a greater world weaver than even he imagined."

The reunited travelers said goodbye to Shu and to the Jenfu, which took some time, since the Jenfu kept asking Regina to sing one more song. Finally, Larkin turned to his friends. "Remember how we did it before?"

"Right," they chimed in as they clasped hands.

"Hold tight. We'll be back on Earth in a few seconds."

This Ends Book I of The World Weaver Trilogy